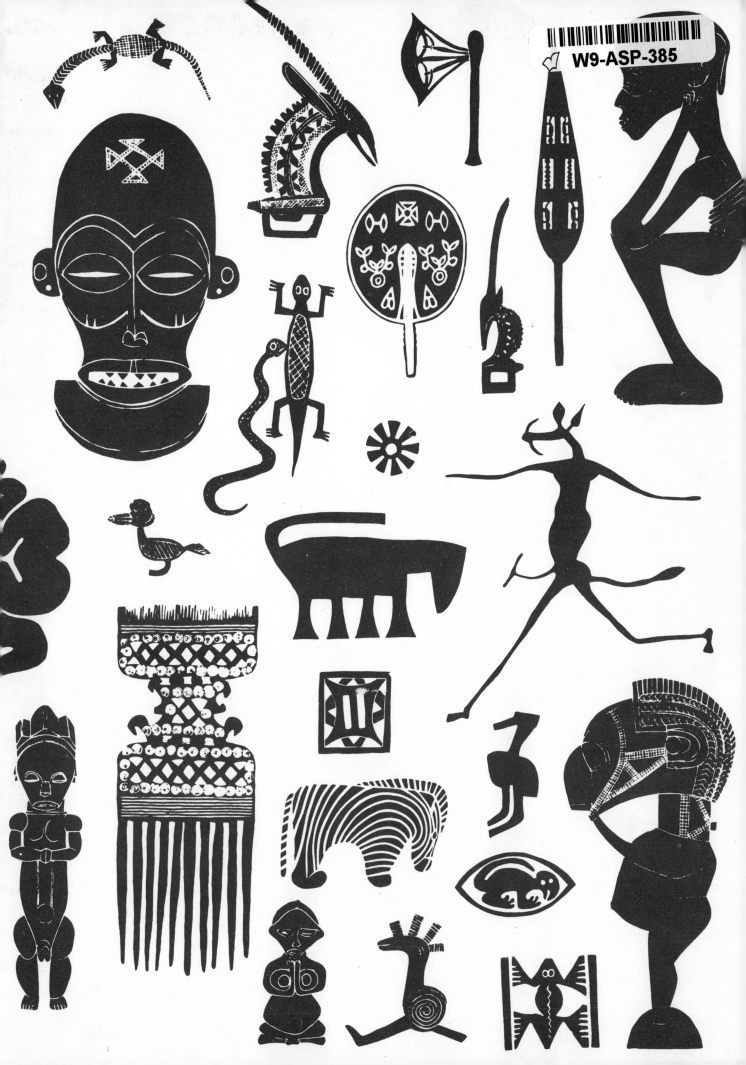

AFRICAN ART

AN INTRODUCTION

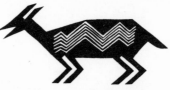

AFRICAN ART
AN INTRODUCTION

Dennis Duerden

HAMLYN
London · New York · Sydney · Toronto

Published by
The Hamlyn Publishing Group Limited
London · New York · Sydney · Toronto
Astronaut House, Feltham, Middlesex, England
© Copyright The Hamlyn Publishing Group Limited 1974

ISBN 0 600 34853 9

Phototypeset in England by
Filmtype Services Limited, Scarborough
Printed in Czechoslovakia by Polygrafia, Prague

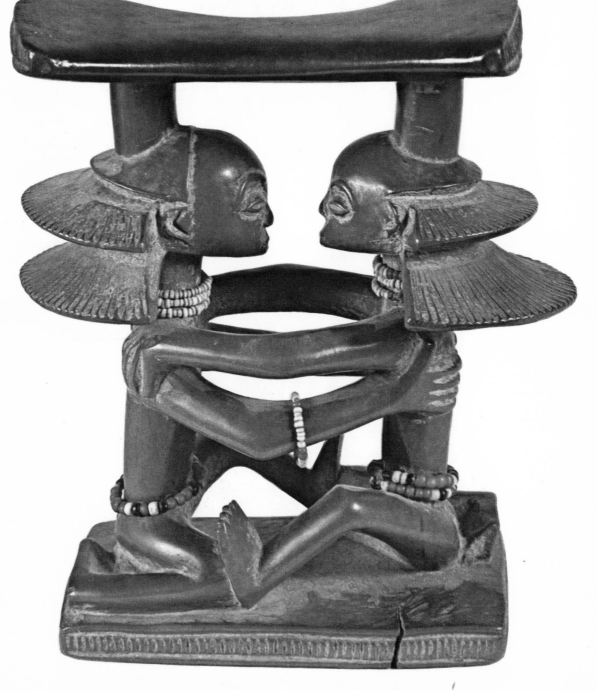

half title page
1 Calabashes, Cameroon. Private collection. The
calabash was an important decoration for a young
bride's room. Later in her life calabashes would come to
signify such events as the birth of a child, or could
indicate that she was the mother of several children or
the senior wife. (It was also common for women to
signify important events by body decorations,
hairstyles, and the way in which they tied their
headscarves.)

above
2 Baluba headrest, Zaire. British Museum, London. This
carving shows how objects of everyday use were made
with as much skill as ritual objects. It also clearly
demonstrates the forms created by the rhythmic use of
an adze (see page 63).

CONTENTS

Key to the principal peoples and places mentioned in the text
Names and boundaries as on 1st January, 1974.

Abydos 1	Bakuba 36	Bangwa 26	Bena Lulua 35	Ibo 21	Mbwela 40	Senufo 9
Afo 19	Bakwele 29	Bapende 34	Benin (Edo) 17	Ife 14	Mumuye 16	Tassili 2
Ashanti 12	Baluba 39	Basonge 38	Bobo-fing 6	Igala 18	Ndengese 37	Toma 10
Bafo 24	Bambara 5	Bateke 31	Bwa 7	Ijo Kalabari 22	Nok 15	Urhobo 20
Bakongo 32	Bamileke 25	Baule 11	Hoggar 3	Makonde 41	Nubia 4	Yoruba 13
Bakota 30	Bamum 27	Bayaka 33	Ibibio 23	Marka 8	Pangwe 28	Zimbabwe 42

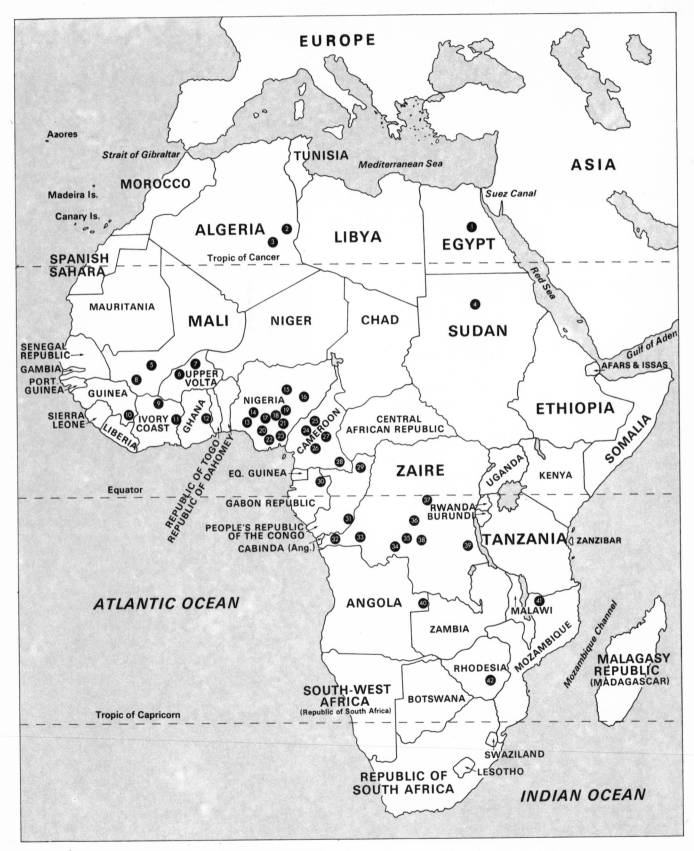

INTRODUCTION

Western art is always on display, hanging on the walls of houses or in museums or illustrated in books. The African society which produced the masks and figures which we see in museums and books hid them away for most of the year. They were only brought out very briefly on special occasions. Masks and figures were used on a great many occasions throughout the year but each one was usually made for a specific ceremony, and therefore very few appeared on several successive occasions. Even fewer of them were openly displayed in a public place. The decorative arts existed openly (house-posts, doors, calabashes, clothes, harnesses, mats, and a thousand useful objects), but the art which has been prized in Western museums since the end of the nineteenth century (by which time twenty thousand objects had already been amassed in collections in Europe) is the art of the ritual ceremony, which was usually kept hidden away during the time when it was not in use.

We can read about a festival in Achebe's *Arrow of God* to understand this.

'It was also the day for all the minor deities in the six villages who did not have their own special feasts. On that day each of these gods was brought by its custodian and stood in a line outside the shrine of Ulu so that any man or woman who had received a favour from it could make a small present in return. This was the only public appearance these smaller gods were allowed in the year. They rode into the market place on the heads as guardians of their custodians, danced round and then stood side by side at the entrance to the shrine of Ulu. Some of them would be very old, nearing the time when their power would be transferred to new carvings and they would be cast aside; and some would have been made only the other day. The very old ones carried face masks like the men who made them, in the days before Umuaro

abandoned the custom. At last year's festival only three of these ancients were left. Perhaps this year one or two more would disappear, following the men who made them in their own image and departed long ago.'

Old or traditional African art, therefore, is the product of a society which did not regard a work of art as an everlasting memorial to the genius of the man who made it or to his patron. Individual artists gained a reputation during their lifetime, and people may have come from as much as a hundred miles away to buy their work, but this work quickly disappeared and the names of the individual artists were forgotten in two or three generations. Nevertheless the skills of individual artists were handed down with the most remarkable continuity of tradition, because it can be seen to have lasted for over eight thousand years. There is a remarkable continuity to be seen in the form and style of masks depicted in Saharan rock paintings during the seventh millennium BC and masks which have been made very recently in the Ivory Coast and Cameroon. The individual artists who produced the masks were not remembered and very few pieces of their work exist which are more than a hundred years old, but their particular kind of vision has lasted for thousands of years. We might tentatively suggest that this vision derived from a very profound understanding of nature in one of the earliest societies to tame wild animals and turn them into the domesticated species that we know today. It was also a society which prized an oral tradition and regarded it as superior to written records. It produced cave paintings, but in inaccessible and remote places which were only used for the initiation ceremonies of new generations. Consequently it did not regard the preservation of visual works of art as of any importance and painted new forms indiscriminately on top of the old.

3 Door-post of Yoruba chief's palace, Idanre, Nigeria. British Museum, London. Carved pillars holding up the roofs of the houses of important members of the community can be seen in all the towns of the Yoruba-speaking people of the western part of Nigeria.

4 Adinkra cloth, Ghana. Linden Museum, Stuttgart. The designs on this cloth were made with small blocks carved from the silk-cotton tree with handles of bamboo strips fastened at the corners and tied.

5 Yoruba carved door, Nigeria. British Museum, London. Carved doors like this one could once be found connecting rooms in the big houses of the Yoruba-speaking people. Among Nupe-speakers north of the river Niger in Nigeria, carved doors were given to brides on their wedding day and taken down and forgotten three weeks after the bride had decorated her room.

3

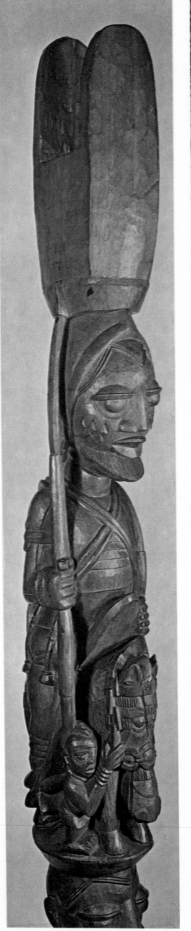

4

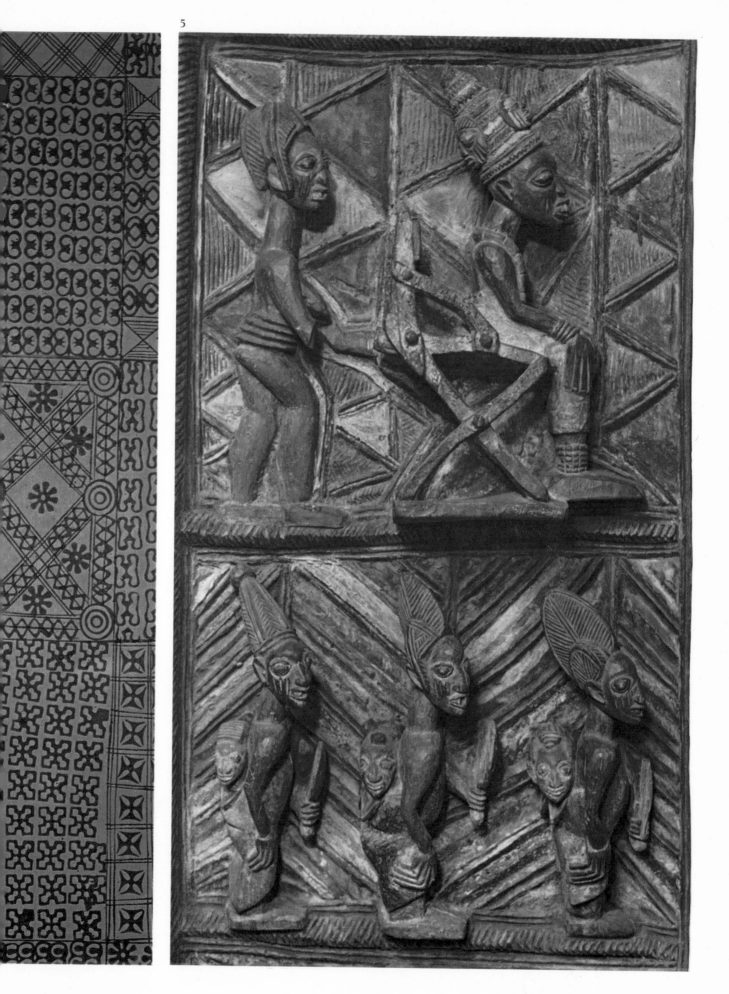

6 Mask at Anouanrhet, Tassili n'Ajjer, Sahara, Algeria. The problem of interpreting cave paintings leads to many wild conjectures. This painting depicts a mask which resembles the masks made recently in Mali and the Ivory Coast. A likeness to the gold head of Tutankhamun has also been observed. An examination of Tassili paintings, however, reveals that the artists were very concerned with optical effects (with what we see, for example, when an object is viewed frontally as well as in profile).

7 Rock painting from Tanzoumaitak, Tassili n'Ajjer, Sahara, Algeria. Carbon dating places these figures between 7000 and 6000 BC.

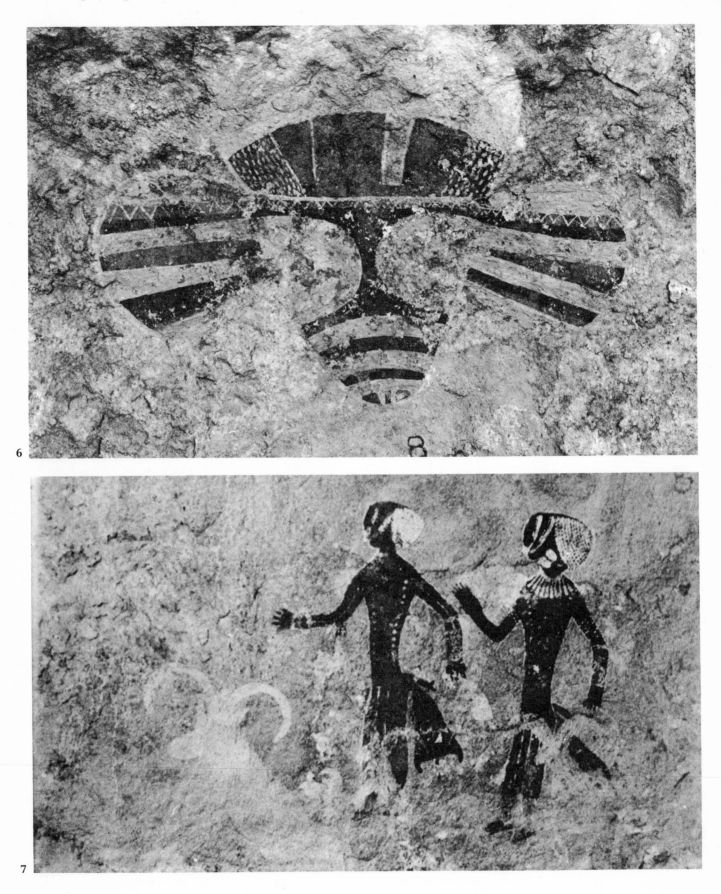

6

7

10

AFRICAN SOCIETY
and the geographical and historical background

A look at the map of Africa shows that the area in which most of the art illustrated in this book is concentrated is extremely small in proportion to the huge land mass of the continent. Obviously there is a great deal of art on the African continent which is not described here, Islamic mosques and manuscripts in the Mahgreb (North-west Africa) and modern Egypt, and Coptic Christian churches in Ethiopia, to name the most obvious. Why then have we chosen to give the name African art exclusively to what is included? There is no doubt that there is a particular kind of art in Africa which is unique to the continent and can be found nowhere else in the world. It is an art which is especially exemplified by the mask and the masquerade in which the mask is used. The masquerade is a particular kind of theatre which will be described later in this book and which is intimately related to the origins of a people whose life depended on an understanding of animals, plants and the seasons. Whenever Islam or Christianity impinged on the life of these people it was introduced by invaders in whose interest it was to detach the local inhabitants from their dependence on the rules of behaviour demanded by agriculture and seasonal change.

Although to us such rules would be constricting, to the Africans they were the basis for their whole way of life, and for the art which it produced. The way of life and the art have been confined in our millennium to an ever-narrowing area and have been rapidly disappearing in the last fifty years. I have used the past tense throughout this book to talk about the old kind of African art because, although it is often still being made and used, more and more of it is disappearing every day. Thus we cannot be certain what has survived and what has been lost altogether at the time this book is published.

One of the features of African art is its continuity.

Masks of certain recognisable types are worn by figures in rock engravings and rock paintings of 6,8-11 eight thousand years ago. Most of these rock engravings and rock paintings dating from pre- 7 history are to be found in inaccessible plateaux in the middle of the Sahara desert, and from the testimony of the paintings it appears as if many of the ideas which were found in Egypt and Greece could easily have originated there (for some of this evidence, see page 82). A great deal of research needs to be done on the African origins of Ancient Egyptian and Greek religious ideas because a distorted idea of the nature of African art has arisen from trying to look for influences arriving in the reverse direction, that is from east to west instead of from west to east. This was possible because the Sahara was capable of supporting a large population with a socially developed culture. In fact, in the millennium between 7000 BC and 6000 BC, the large mountainous region in the centre of the Sahara desert was full of wild animals now found in areas of Africa much further south. The vegetation of the area was very similar to what is called the 'orchard bush' and is now the vegetation of the area between the savannah fringes of the desert and the rain forest.

The centre of the Sahara remained like this until about 4000 BC when it began to dry up, so that by about AD 400 it had become very much the hot, waterless, sandy desert that it is today. During the three-thousand-year period when the central Sahara was wet with numerous rivers and thick vegetation, the Neolithic hunters and fishermen who lived there made engravings on the faces of the rocks, of which about thirty thousand have been recorded. A similar number of paintings have also been discovered. Most of these engravings and paintings are representations of wild animals, of elephants, rhinoceroses, giraffes and ostriches, and in particular an extinct buffalo, *bubalus antiquus*, which is 12

8 Bamileke masquerader, Cameroon. The protruding ears of this Bamileke masquerader are said to represent the ears of an elephant.

9 Bamileke masquerader, Cameroon.

10 Senufo 'fire-spitter' mask, northern Ivory Coast. The horns, the smooth round skull, and the elongated jaws of this mask are characteristic of masks throughout the area of the Ivory Coast and the surrounding territories.

11 Baule mask, Ivory Coast. Collection Eduard van der Heydt, Rietberg Museum, Zurich. This mask belongs to the general family of masks from this area. This photograph, however, shows how the indentations in the sculpture could have been represented in the Saharan rock painting mask (plate 6).

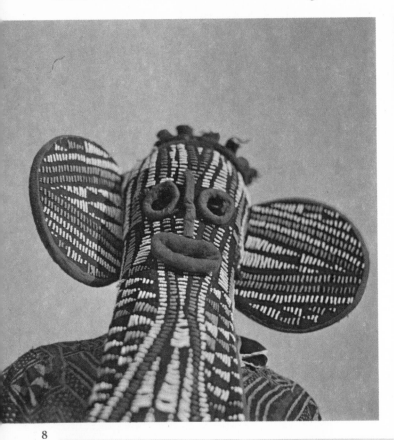

8

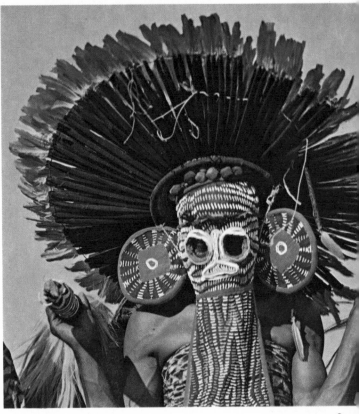

9

10

12 *Bubalus antiquus*, **Tassili n'Ajjer, Sahara, Algeria. The prehistoric, wild buffalo of the Sahara, ancestor of the bush cow, a dangerous animal like a buffalo which now lives on the fringes of the Sahara.**

related to an animal which is still common in the savannah and the orchard bush at the south-western periphery of the Sahara desert and is known locally as the bush cow. The bush cow is an important model for representation in African masks made nowadays in the areas surrounding the Sahara, and *bubalus antiquus* was a model for masks which are represented in paintings found in the central Sahara and which we know to have been made over seven thousand years ago (their antiquity has been established by carbon dating).

When we look at the evidence of previous life in the Sahara, we can see the shifting population of the region in the successive stages of animal symbolism in the rock engraving and paintings and relate them to the art and beliefs that still exist in Africa today. As the Sahara dried up (and the process of dessication may have been assisted by the practice of shifting cultivation adopted by the hunters themselves), the animals moved southwards and the hunters followed them. The hunters were then replaced by pastoralists who had already moved in slowly and lived at first as the hunters' neighbours. In fact it appears from the paintings and engravings as if wild animals were being domesticated at an early stage. The pastoralists' mode of life was similar to that of people who live in the savannah areas surrounding the Sahara at the present day. They painted pictures in which they represented the animals they had domesticated, and their everyday life and ceremonies. Because 13 the hunters and pastoralists existed side by side for a while, and because the pastoralists had originally tamed wild animals, there were important similarities in the art and symbolism of the two kinds of peoples.

When the centre of the Sahara became too dry to support more than a very few nomadic pastoralists (and some Tuareg people still live there), there was a further movement out to the fringe, and the successors to the hunters and shifting cultivation drove these latter people further southwards deep into the equatorial forest. Finally an increase of population on the Saharan fringes and the creation of warlike kingdoms encroached on the people occupying the forest areas so that they in turn migrated further south into the savannah areas of Central and Southern Africa. They carried with them all the cosmological ideas they had evolved in the Sahara.

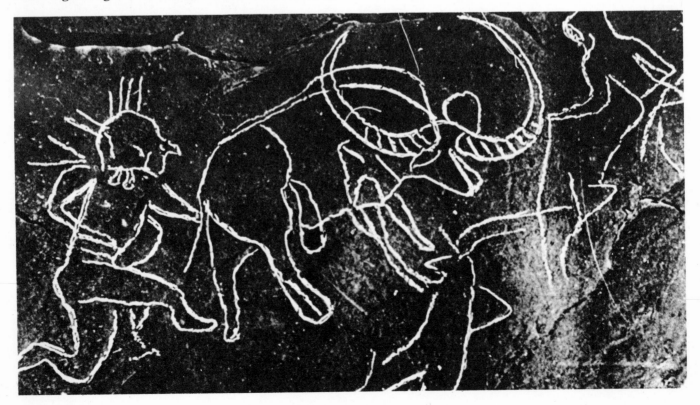

13 Rock painting from Haut-Mertouteh, Hoggar
mountains, Sahara, Algeria. Found in a shelter on the
southern side of the Saharan central massif, the huge
headdresses on these figures look similar to those of
modern nomadic pastoralists, such as the Fulani.

14 A house in the northern part of the Sudanese
Democratic Republic. Decorations of this kind are to be
found on houses of followers of the Islamic faith all over
Africa. However the crescent and the disc above it
recall the symbols of the old kings of Africa, the horns
and the sun (see plate 86).

15 Hunter carrying an antelope, Benin, Nigeria.
British Museum, London. The hunter was represented
as understanding the animals he captured by
acquiring a spiritual and physical resemblance to them.

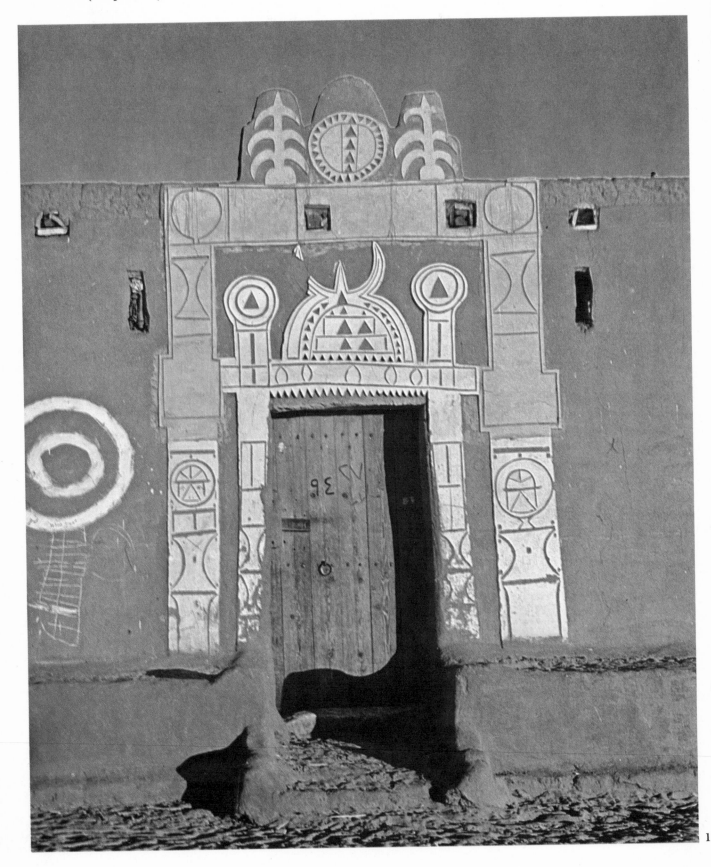

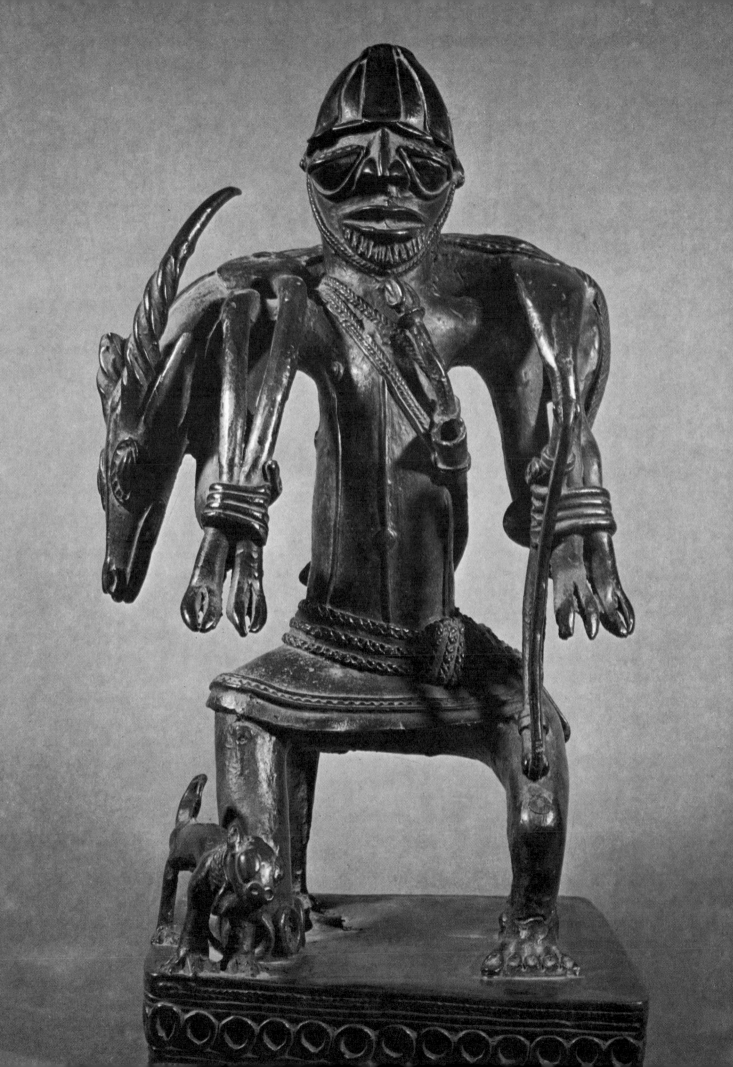

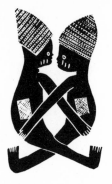

AFRICAN SOCIETY
and the mythological background

The social pattern

Most of the people whose art we illustrate live to the north and south and actually in the thick forests on the equator, and seem to have spread to those areas from a point close to Lake Chad in the millennia before our era. They usually speak languages belonging to a group known as Bantu.

Early observers classified and named the communities they met according to the language spoken by the people. However most of the people who spoke the same language did not form a homogeneous entity which we would call a tribe. When we give a name such as Yoruba or Bayaka to a particular group of people we should remember that this means that they spoke a similar language, not that they belonged to a tribe of that name. Generally they regarded themselves as belonging to a clan, that is they thought they belonged to a group of people who could trace their descent back to a common ancestor although the line of descent might not be remembered exactly. Some of these people belonged to royal clans, that is clans from which a king might be chosen who might rule over the whole group that spoke the language of those clans and lived within the boundaries of their territory.

The clans might be made up of lineages, that is families who could trace an exact descent to a common great-grandfather or grandmother or even to a particular individual one or two generations before that. These people would inherit their land and wealth through the line of descent in their lineage and would be represented by an elder at meetings of their village or clan. This elder would be chosen from the most able-bodied and responsible men in each lineage group, and would usually be given respect and obedience by the younger members of the group.

On this basic pattern a complete system of beliefs was built up to formalise and ritualise the needs of the social structure. As in the constitutions of modern states, there was an elaborate interlocking network of checks and balances to make sure that, while the social structure was a stable one, it was not so unchangeable as to become unworkable by failing to adapt to changing circumstances or a new environment. This was clearly essential for a community on the move – either of hunters following game herds in their search for pasture, or pastoralists forced by drought or hostile invaders to find new land.

Order and disorder

It is clear the art of sub-Saharan Africa was the art of a people constantly moving westwards and southwards, led by hunters who had developed special skills of adaptation. In doing so these people created men's initiation societies throughout Africa in the south and west of the Sahara, expressing the young adult man's role as an agent of change with a responsibility for seeing that change took place without damaging the older form and rhythm of the society. That is why the most important features of the mask were their capacity for transformation, their power of emerging from the leaves of the forest or the savannah and then disappearing again like camouflaged animals. We shall see that a society in which hunting was of special importance produced masks which showed a highly developed understanding of these optical characteristics. At the same time these societies produced myths in which hunters were the leaders and initiated the process for understanding the changes that might need to be made when the societies migrated to new environments. Such societies kept these myths as part of the process of their constant migration south from the Sahara.

In recent Central Africa, in modern Zambia and the Congolese Republic, for example, groups of young men leave their matrilineal villages to form new villages, and are led by renowned hunters who

16 Bronze head with birds and snakes, Benin, Nigeria. British Museum, London. This head could be the head of the queen mother, wearing the birds that we see in the Yoruba king's headdress (plate 20) and with snakes issuing from her nostrils to indicate clairvoyant powers.

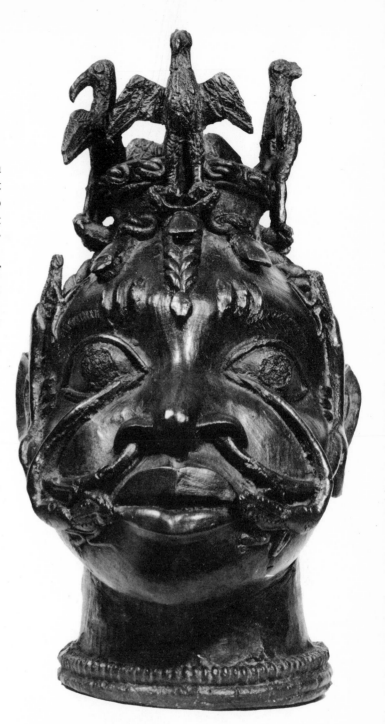

form hunters' cults. The Yoruba of the northern part of Nigeria have a legend that they were brought to their present location by a founding ancestor who was a hunter, called Oduduwa. Many other West African societies subscribe to the legend that their ancestors came from the east, led by a hunter. The matrilineages usually represented the idea of stability and continuity in their society, and might be associated with the founding women of the society who were already in possession of that part of the earth when the men first came there, because even today the men must leave their own matrilineages to seek wives elsewhere. The presence of men from other villages in the men's villages lessens the chances of wars with their kinsfolk. The search for women to marry who are not members of one's own matrilineal clan requires going farther and farther afield. It has been said of the Urhobo in Nigeria, for example, that they find it impossible nowadays to find someone to marry who is not related to their clan, and that this explains why they so frequently marry Ijo people in the neighbouring territory. The importance of the matrilineage in establishing order is reflected in the importance given to the queen mother in many societies across the whole of Africa.

However the need for the hunters of the society to move onwards, of men to go to other villages to look for their wives, and the practice of shifting cultivation so that even the farmers of each village have to move (Yoruba farmers travel farther and farther away from their big towns until they establish new villages which eventually themselves become big towns), means that the principle of change and therefore of productive disorder was built into their society.

An individual could be in an ambivalent position. His or her ability to see the need for innovation might produce a feeling of discontent which would be recognised as good in a group which needed change, or it might simply be regarded as selfish in a group which required a temporary stability. It was equally possible therefore to be a hero or to be treated as what we in the West call a sorcerer or a witch. The earth, the source of fertility and therefore of innovation and change, could produce heroes who became demigods or it could produce witches.

The queen mother, embodiment of the principle of fertility, could also unleash the witches in her service. The queen mother produced the king who established a more permanent order with instruments which were given him by the sky, but she also encouraged change and the overthrow of established order. She produced an individual who imposed his particular personality on the whole society for a limited period, but she could also dethrone him and set up a new individual with a new personality to impose a new order. She was regarded as bisexual, and thought to be the instrument of her own fertility; she was related to the witch who had the snake in her belly. The progenitor of the gods of the Fon of Dahomey was Mawu-Lisa,

17 Horned 'goddess' of Anouanrhet, Tassili n'Ajjer, Sahara, Algeria. The bar with the feathery appearance and the screen of spots have been interpreted as a field of corn scattering its grain, thus making the figure a corn goddess. Could it instead be a veil sheltering the crops from her gaze? The horns predate the horns to be seen on figures of Isis (plate 86).

18 Gelede cult mask, Yoruba-speaking people, Dahomey. The Gelede society is a woman's cult concerned with the discovery of women with clairvoyant powers who may be using them for malicious purposes, hence the bird, symbol of malevolent clairvoyance in such circumstances.

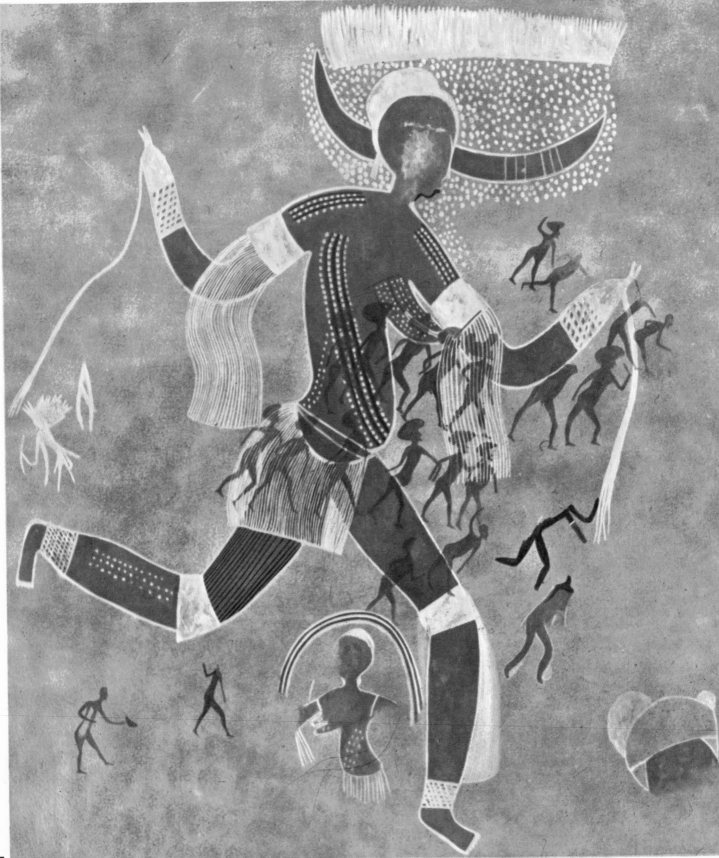

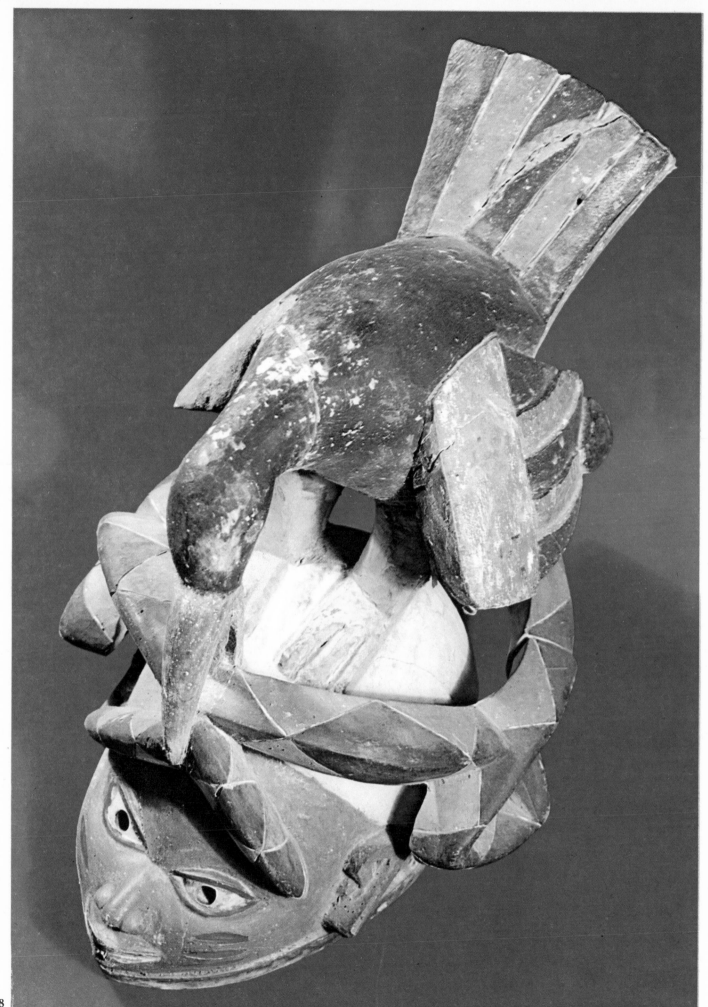

who was both female and male, the earth and the rainbow, was also represented by the snake.

The woman with the snake in her belly, who became the witch when she was an aggressor, was also an important feature of the acephalous societies, that is societies without kings, which were more common in Africa than the kingdoms. The word 'witch' has the connotation of evil in European and American societies, stemming from the beliefs of medieval Christianity about witches. However it must not be assumed that a witch was regarded as totally evil in Africa, since the powers of witches could be used for good if they were used to produce change and introduce new ideas into the society. Consequently the new generation of young men and women formed societies in which they might be allowed to use the powers of witches, and these societies were associated at the same time with art and entertainment. An aggressive person who wanted to change the group might be called a witch, but if the aggression engendered by their powers of second sight was proved to be a valuable asset, then it could be used to help the group's adaptation to new circumstances. Any attempt to suggest change was regarded as aggression by those in possession of society at that particular time, and could only be expressed acceptably by the witches as ritualised aggression

The new mask carved by the priest's son in Achebe's *Arrow of God* is to be used by the Otakagu age-groups, and we see there the rivalry which made their role similar to that of someone using witchcraft: 'In the past few days there had been a lot of coming and going among members of the Otakagu age-group. Those of them who had leading roles to play in the ceremony would naturally be targets of malevolence and envy and must therefore be "hard-boiled" in protective magic.' It appears then that the role of the man wearing a mask was that of someone with powers which might bring prosperity or might bring calamity. In electing to wear a mask he took the same risk as someone choosing to use witchcraft, the risk of being praised for introducing a necessary discord, or of being rejected for introducing envy and hate. This was a risk which was also taken by the initiate with the Ekine society of the Kalabari Ijo, as we shall see later when talking about his need to

understand the rhythms which expressed the clan personalities in the society (see page 51).

It is also possible to point out the visual effects used in the masks to express this sense of the duality of individuals as agents both of order and disorder. Such visual effects were not confined to the masks of the men's society. For example, the Gelede 18 society of the western groups of the Yoruba was a woman's society used for the control of witches. The masks were always made hard and smooth, their overall appearance like that of eggs. The masks spun round first in one direction and then in the other. During the gyrating movement the head had the appearance of an egg. When it came to rest the features appeared; the egg had been transformed once again into a face or group of figures.

The sky and the earth

This duality pervaded every aspect of the life and art of the community. It was accepted that some members of a society would try to change it in order to make it more acceptable to new conditions. It would be the task of others to try to arrest change 19 and to express all the durable and lasting elements in the society. When discussing the masquerades we shall see that the duration of order and change was reflected in the type of masks used and that the two types appear together. It was also apparent that the life-force in nature which was at the disposal of society was capable of taking on the characteristics of inflexible order in the hands of a particular individual or on particular occasions, while it worked towards change and disruption when working through other individuals or in other situations. The two concepts of the life-force were symbolised by the sky and the earth. The sky symbolised order and permanence because it regulated the unchanging parts of the pattern of people's lives, night and day and the seasons.

Consequently, the sun and the gods of the sky were seen as imposing a regimen on the earth, one that was voluntarily accepted, but was nevertheless often regarded as an unfortunate necessity. For example, the myth was widely told that the earth quarrelled with the sky so that the sky withheld rain, and life on the earth began to dry up. Then the earth sent a bird as a messenger to the sky, and

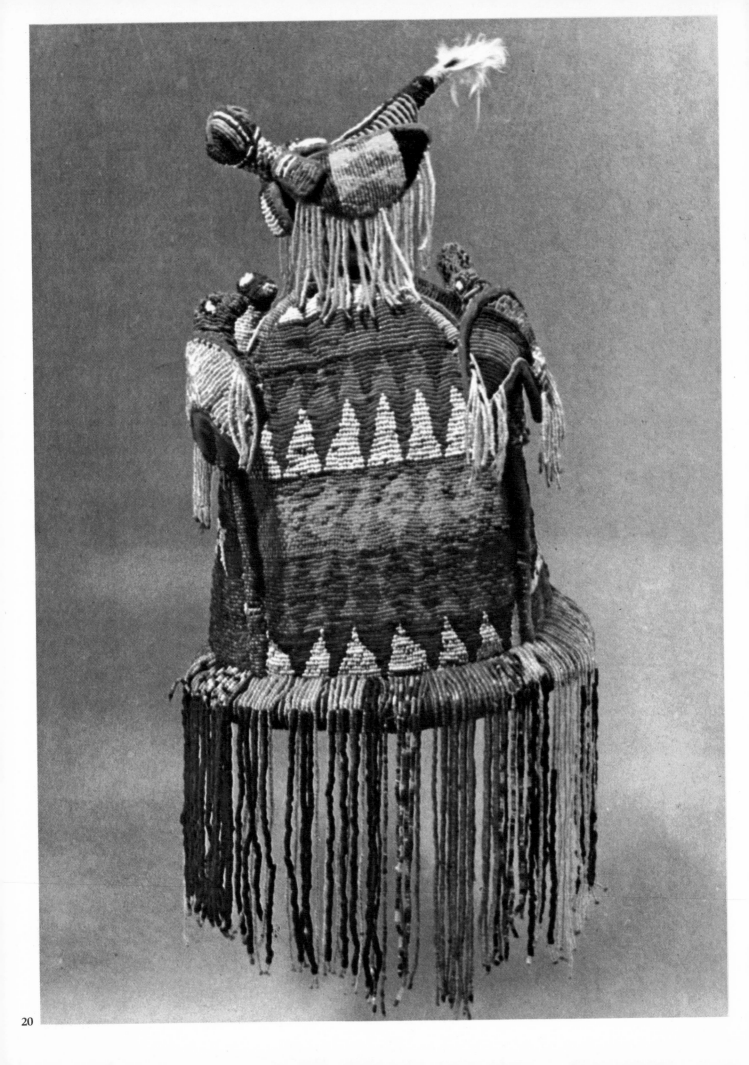

20 King's headdress, Yoruba, Dahomey. Musée de l'Homme, Paris. The veil was to shelter the group from the power of the sky gods to whom they dedicated the king. He interceded with the gods on their behalf. But his crown also carried birds which symbolised the earth's ultimate power over the sky gods.

21 Pangwe figure, Gabon and Cameroon. British Museum, London. (The Pangwe group of people are often referred to as Fang.) This ancestor figure was mounted on a box containing ancestral relics. It shows the continuity of this tradition right through the belt of the equatorial forest in which the Pangwe group of people live.

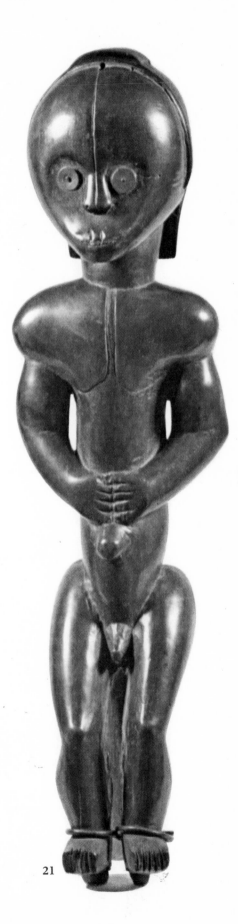

21

the bird interceded on behalf of the earth, and the sky relented and sent rain. The bird is an important feature of this myth because birds had great power in their capacity to act as messengers of the earth to the sky. Despite the fact that the sky could harm life on the earth by withholding rain, the earth was held to be superior to the sky; it was in fact the source of the life-force and therefore its messengers, the birds, had a particular significance as arbiters of power. That is why we find the bird on the Yoruba king's headdress. It signified the power of the earth over the sky. It was significant of the dualism that birds were also controlled by witches.

7, 20 The headdress of the Yoruba king and some other African kings is seen to have a veil. The veil symbolised the fact that the gaze of the king could harm any subjects upon whom he looked directly. He had been chosen as a channel for a very strong force which could also be a very dangerous one. The king of the Onitsha Ibo people is not allowed to look at the growing crops in case the force for which he is a channel should burn them up.

The king and his court were therefore seen as a storehouse of the force or power preserved on behalf of the community. When their power waned so did that of the community. (The Bakuba *ndop* [see page 30] contained the king's life-force and that is why it was supposed to show any injuries inflicted on the king.) This meant that the king had not to be seen to be deformed or ill and his death was often kept secret until his successor had been chosen. A king's death was sometimes followed by a period of social chaos until his successor could be installed. On the other hand a king's reign had not to last too long, and in many cases his successor was chosen so that the force controlled by one king in one family should not become too great: otherwise the community would suffer from a concentration of force in one person or family.

22 Perhaps this is why the palaces of the Bamileke kings were said to burn down every ten years. The fire generated by their conservation of power destroyed them from within. It has been often suggested that the so-called 'divine king' in Africa was killed by his successor as soon as he became too weak to resist. In this way the king could reflect the natural health of the society and be made to give up his office as soon as he was no longer

22 Façade of a chief's palace, Bamileke, Cameroon. Said to burn down every ten years these Bamileke chiefs' palaces are difficult to find, and are often discovered at the end of winding paths and in thick groves. The king, as a channel for the spirits, had to be hidden away. Notice the chameleon on the carved post, symbol of the king's adaptability.

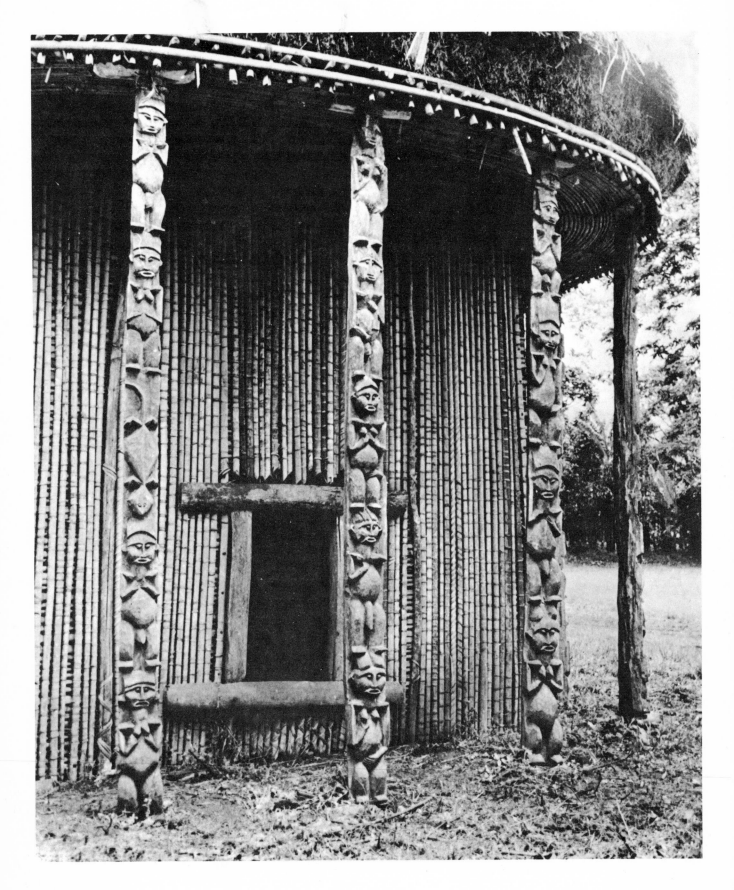

23 Masqueraders, Afikpo Ibo, Nigeria. The masqueraders in this illustration are wearing the kind of mask which is of the opposite type to the one in plate 68. It characterises an elder with known imperfections, but the imperfections are regarded as natural in anyone who has assumed his responsibilities. They are pointed out to remind him that they are tolerated so long as he serves the community.

strong enough to hold it. It is however more likely that the king was in danger of losing his office if he succeeded in conserving too great an amount of power for himself and his family.

The personality, and hence the art, of elders and kings was never allowed to become so obtrusive that it was obstructive to the growth of personality in each individual as a member of a clan and as a contributor to the development and fertile continuation of the clan. We should bear this principle in mind when looking at any work of African art produced in the past.

The Okumpka plays of the Afikpo Ibo make a very similar statement to the one made by Ihuoma in Amadi's novel, *The Concubine* (see page 29). They say that goodness and beauty may be a difficult burden and that all human beings are capable of anti-social actions; they also say that these actions

are ambiguous, that it is not always easy to tell whether they are valuable to the group or are harmful. A young man may have a serious disagreement with his social group and his disagreement needs to be brought out into the open. Elders should look at the dark side of their nature which is given them by the earth, representing the need of everything possessed of the life-force to assert its difference from every other individual and to try to impose its particular character on its environment. At the same time those who are given beautiful features should realise that they do not always work towards the social good and these masks are themselves deliberately ambiguous because they not only have the form of beautiful women but could also be taken to be apes. In the Afikpo Ibo Okumpka plays and in many other plays 23,28 of the age-group societies throughout Africa, good

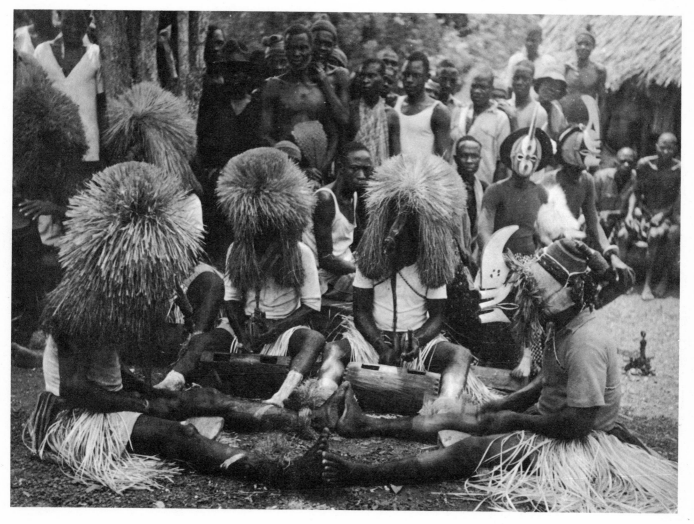

24 Human hand and three figures, Wadi Sera, Libya. The hand outlined is the right hand, the hand of life. As in many other Saharan rock paintings, the figures are dancing in the characteristic posture of West African women as seen at the present day.

25 Festival of Yemoja, Ibadan, Nigeria. This illustration and the next show how the figures representing the gods and goddesses of the earth, associated with fertility, were brought out during a festival every year so that their life-force could be created to make the crops grow and the women have children.

26 Festival of images, Ilobu, Nigeria. At the festival where the figures of the fertility gods appeared, the gods associated with them, such as Ogun, the god of iron, were also summoned to appear by drumming and dancing.

27 Ogiyan shrine, Ibadan, Nigeria. For the rest of the year the figures were kept in a shrine, and the gods given offerings so that they should remain in the community.

24

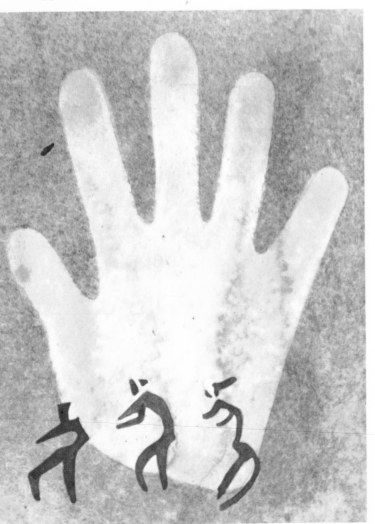

and evil, beauty and ugliness were relative, because the most important value was the well-being of the social group, but the social group was originally of dominant importance in the plays only because it supported life. If old African art asserted a value it was the cultivation of the life-force and consequently of fertility. The rhythm in the carvings expressed the life-force in the form it took in various individuals.

It is particularly illuminating to bear the relativity of good and evil in mind, for example, when we look at the symbolism of the Ogboni society of the Yorubas. At Ogboni society ceremonies sacrifices were made to Ila, the earth goddess, and an old woman had always to be present to carry out the rituals of the cult. The Ogboni society, however, symbolised its power by arranging everything on the left hand and the left hand represented both death and ill luck. In most African societies to give someone an object with the left hand is taboo because it will bring him ill luck. Outlines of human hands have been drawn on walls in Africa 24 from as far back as the time of the early rock paintings, but the hand outlined is usually the right hand. By using the left hand in all its ceremonies the Ogboni society symbolised the fact that it was also the left hand of the king because the king's left hand was the hand with which he pronounced the sentence of death, and the Ogboni society was the executive arm of the Yoruba king. It saw that

criminals were brought to justice and handed over to Oro, the young man's cult which carried out the sentence and announced its presence at night by the use of the bullroarer, which made a fearful sound which kept everyone indoors. Thus we can see that the Ogboni society, which both made and unmade the Yoruba kings, by having power over both life and death, expressed the African concep-

31 tion of the earth as the source of life but also as the place to which the dead returned in a continuous regenerative process.

The fact that the cults of the earth are also concerned with the life-giving force was to be found in

25 the Yoruba cults of Ogiyan and Yemoja, in which the images of the shrine were taken out to be used in a dance during the rains. At one shrine of Yemoja which, like the one with the dancers in the illustration, is in the city of Ibadan, the figures were kept in a hut near a stream and the priest who looked after them lived in a tree for seven days during the festival. The tree was surrounded by water at the height of the rains and a five-feet-long fish was said to swim up to the tree if the requests of the women for children were going to be answered. Taking out fertility figures on women's heads for dancing at festivals during the rains was a very common practice in the whole area of Africa which we are considering. In plate 26 we can see it happening during the Yoruba festival of images at Ilobu in the western part of Nigeria, and here the images of the

pantheon connected with the earth and fertility, including Ogun, would be used in the dancing. In plate 27 we can see the figures of a fertility god, Ogiyan, in their shrine. Ogiyan was represented by both a male and a female figure. The male was shown hoeing, the female had a child on her back. The connection between the fertility of the farms and the fertility of the woman was explicit.

Here, as everywhere, there is duality. On the one hand we find a striving of the earth's fertility towards innovation and change, and on the other the attempt of rulers to impose order and hold society to its obligations to obey a fixed pattern of rule and order.

It is Ezeulu's misfortune in Achebe's *Arrow of God* that he is bound to conform to the rules that his particular sky or role as interpreter of the village spirit impose upon him. The rigid conformity demanded of kings and chiefs placed them in a kind of prison. Achebe tells us that Ezeulu rarely spoke. Another example from African writing of an individual who is imprisoned by the perfection of her alliance with the gods is Ihuoma, the heroine of Amadi's novel, *The Concubine*. Ihuoma is the wife of a sea god who begs him to let her live on earth, but the sea god is jealous. All her husbands and suitors on earth die, and Ihuoma is too perfect for the society in which she lives.

'As her prestige mounted its maintenance became more trying. She became more sensitive to criticism

and would go to any lengths to avoid it. The women adored her. Men were awestruck before her. She was becoming something of a phenomenon. But she alone knew her internal struggles. She knew she was not better than anyone else. She thought her virtues were the product of chance. As the days went by she began to loathe her so-called good manners. She became less delighted when people praised her. It was as if they were confining her to an ever-narrowing prison.'

This necessity of gods and their slaves, priests and kings to appear perfect, an unavoidable burden, is also expressed by the lawyer in *This Earth My Brother*, a novel by the Ghanaian, Kofi Awoonor, when he sees the President going by in his car sealed off from the rest of the world, and remarks, 'I bet he doesn't shit'. In the past kings were not supposed to be seen eating or defecating. They were hedged about with prohibitions imposed in order that they should appear more perfect than other people. That is why they were chosen from special clans, and members of these clans would show real or feigned reluctance when chosen to be kings.

Souls and destinies

All individuals had a soul which would kneel before the source of destiny in the sky to obtain its individual destiny. Royal clans would obtain a destiny from the sky which they would impose on the nation. The royal clan was given its power by the sky (the eighteenth-century ancestor of the Asantahene of the Ashanti in Ghana was sent a golden stool which dropped at his feet from the sky), and is often said to have come from the east, from the place the sun rises. Because of his particular destiny each king established the order in society peculiar to his particular individuality. At the installation of the Congolese Bakuba king he chose a particular geometric pattern as his sign to be carved on his drum of office and selected his *ibol*, the symbol represented in front of him on his per-30 sonal carved figure, his *ndop*. He then ordered a sculptor to carve his *ndop* and his drum. The *ndop* contained his second soul and therefore he had to be present when the figure was carved. It was therefore called a portrait, although it was obviously not a true portrait. The *ndop* was not supposed to be damaged in the king's lifetime because if it was,

the king would be wounded in the same way. Similarly the *ndop* would show any injury done to the king. (One king's *ndop* was said to show a deep cut when he died from a sword cut.)

Many kings, ancestors and chiefs in Africa kept a collection of objects which symbolised their personality and its attendant soul. After a Basonge chief had been chosen he was given, we are told:

'a leopard skin: symbol of a cunning nature;
a lion skin: symbol of strength;
an otter skin: symbol of intelligence;
a fox skin: symbol of an agile mind;
a hatchet, a bow and arrow: symbol of justice;
a double bowl with a handle: symbol of the life-force.'

They were all put in a chest which was kept in a hut and looked after by a young man and woman chosen to be their guardians ('Arts of the Angolan Peoples', Marie-Louise Bastin).

Why did these collection of objects wield such great power? Perhaps they should be compared to the basket of objects carried by the diviner of the Ndembu, one of the Lunda group of peoples in the southern savannah of Central Africa. By shaking his basket and looking at the symbol which came to the top he could discern what hopes and fears were in the minds of the social group for whom he was carrying out his divination. He was a kind of psychoanalyst at an encounter group of the whole community. His collection of objects played the same role as the beads of the Ife diviner of the Yoruba people of Nigeria. There the beads might be used for individual consultation but their principal role was to inform the diviner what was in the mind of an individual by encouraging that individual to reveal himself to the diviner. A king or chief was credited with second sight which would enable him to perceive matters which embraced the whole community, and consequently this collection of symbols had very special power. At 21 the same time these symbols expressed his particular personality, because while he lived his personality embraced the whole group. They and he were one on the occasions when they were used in the rituals concerning the whole society, and on those occasions he was supposed to be able to detect the dangers and the destructive forces in the society by virtue of the objects he possessed as the chief

agent of divination on behalf of the whole community. Those objects gave him channels of communication with the society's god and they helped him to preserve the features of a particular individual soul, 'to wash his soul', as the Ashanti would say, meaning that they helped him to retain an unclouded perception of the personality of his community and its problems, because his soul had become identified with the community. Thus the Ashanti *kuduo* box had objects placed in it for 'the washing of the soul', and the chief or elder who possessed it used it to preserve his clan's personality. Nevertheless, when he died his *kuduo* box was buried with him because, with his successor, his clan would assume a new personality which would have to be defined in accordance with changing circumstances.

Secrecy is one of the most important factors to be considered when discussing the nature of African art, of the African oral tradition and African religion. The American social anthropologist Wyatt McGaffey, writing about the Bakongo, has said that the tradition varies to suit the audience each time it is told, and that one of his informants said to him, 'If you want to know the straight roads sit in a gathering of only two or three, because when more than two or three are gathered together the road starts winding'. Knowing too much about a man's ancestors gives another man power over him. The diviner's job is to discover the secrets that people are hiding. The masks that dance with the ancestral relics are made bright and shining because a bright, shining appearance gives the impression that the masks are far seeing.

It is easy to see that both the need for secrecy and an art whose power consists in its ability to make people reveal their secrets are essential characteristics of societies whose principle aims and intentions are the harmonious living together of a group. Where aggressive envy is regarded as a menace to the society there must be ritualised occasions on which it can be legitimately released. At the same time it is an ideal of the society to suppress it, for the individual to admit its inevitability in human relationships, but not to want to bring it into the open except under carefully prepared, ritualised conditions. Therefore it is not allowed in the open unless it is masked and its

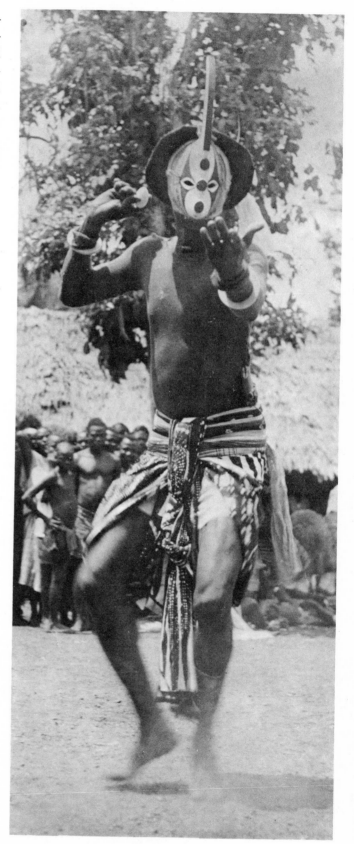

29

31

29 Kuduo box, Ashanti, Ghana. The importance of the treasure chest, which contained the objects possessed by a man to help him regenerate the powers of his ancestors, might also have been linked to the importance of the diviner's basket as the source of his inherited power in Bantu tribes south of the equatorial forest, and also to its importance as a symbol of kingship in some of the Luba and Lunda kingdoms there.

30 King Shamba Bulongongo, Bakuba, Zaire. British Museum, London. Smooth and shining with a large head, the *ndop* of King Shamba shows him with the sign indicating his wisdom, the mankala board, with which he diverted his people's attention from gambling.

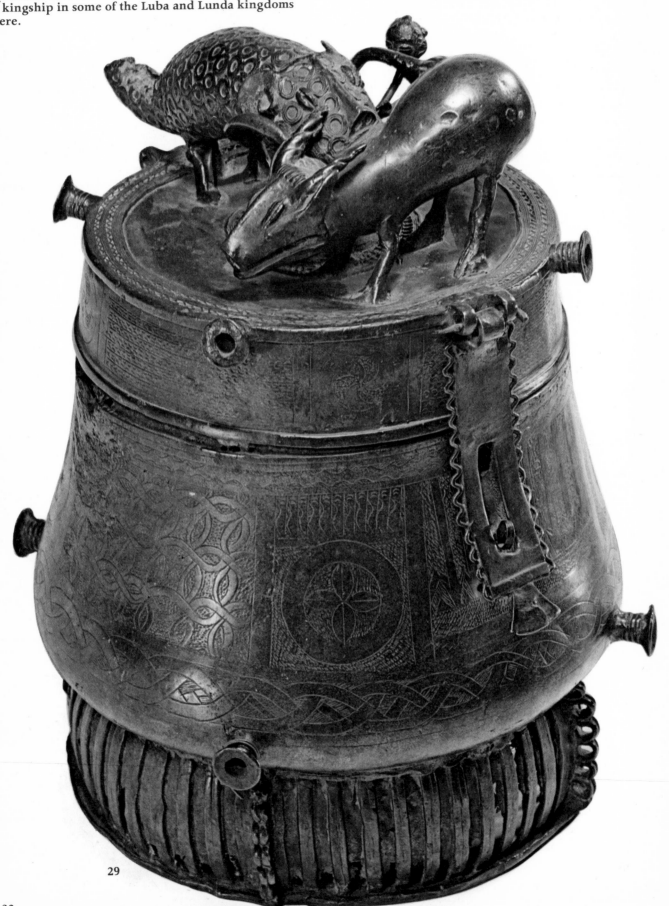

29

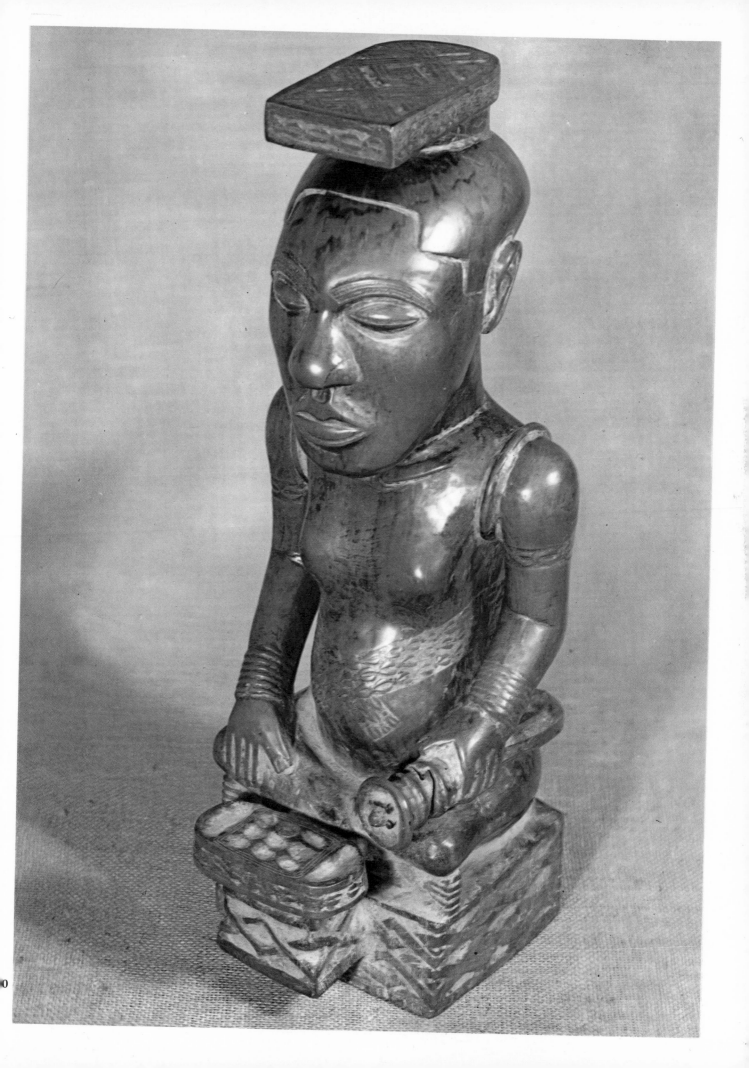

31 Ogboni society bronze, Yoruba, Nigeria. This is a face mask worn at a ceremony by an elder highly placed in the Ogboni society, and it had a similar function, therefore, to the Ashanti kings' masks (see plate 57). But it has dispensed with the rigid severity of a king's mask and expresses the burgeoning and almost uncontrollable power of the life-force.

32 Ci Wara dancers, Bambara, Mali. The Ci Wara carvings on the heads of these elders represent the antelope, one of 'the beings of the wild' who taught men which rules had to be obeyed to survive on earth; that is why they were seen supervising farming operations.

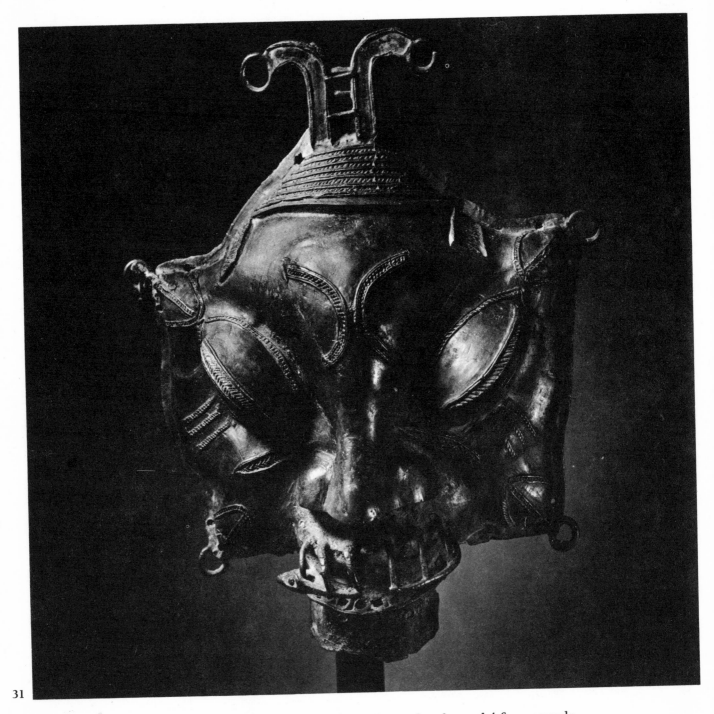

31

33

mask takes on great power. The man who has the power to perceive it, the king, the ancestor, the chief, the diviner also has great power, and therefore the ordinary members of society must be shielded from him. In order to protect their secrets they will form secret societies and cults so that they can unite together against those who are far-seeing—those born into royal clans or those born 'to

dance for the gods' for example.

Thus duality can be seen on every side: clarity of vision and secrecy, court and people, elders and young people's societies, static and dynamic forces, sky and earth, society and nature—all are evenly balanced so that the community may survive. And, as we might expect, we shall find that this duality applies to the art of Africa as well.

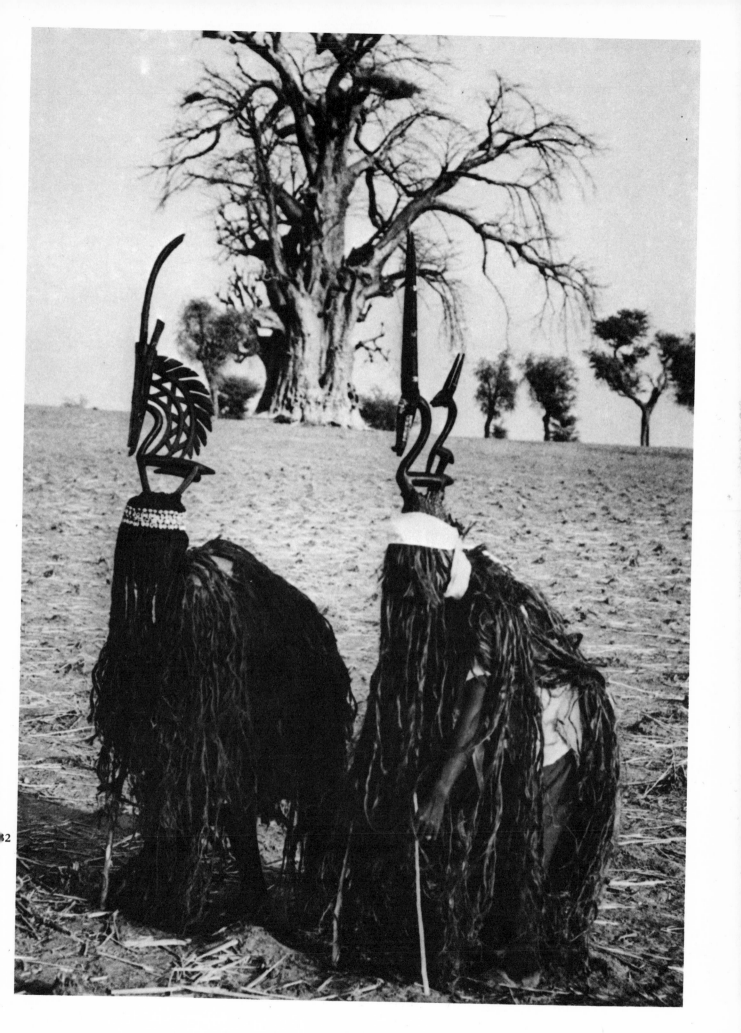

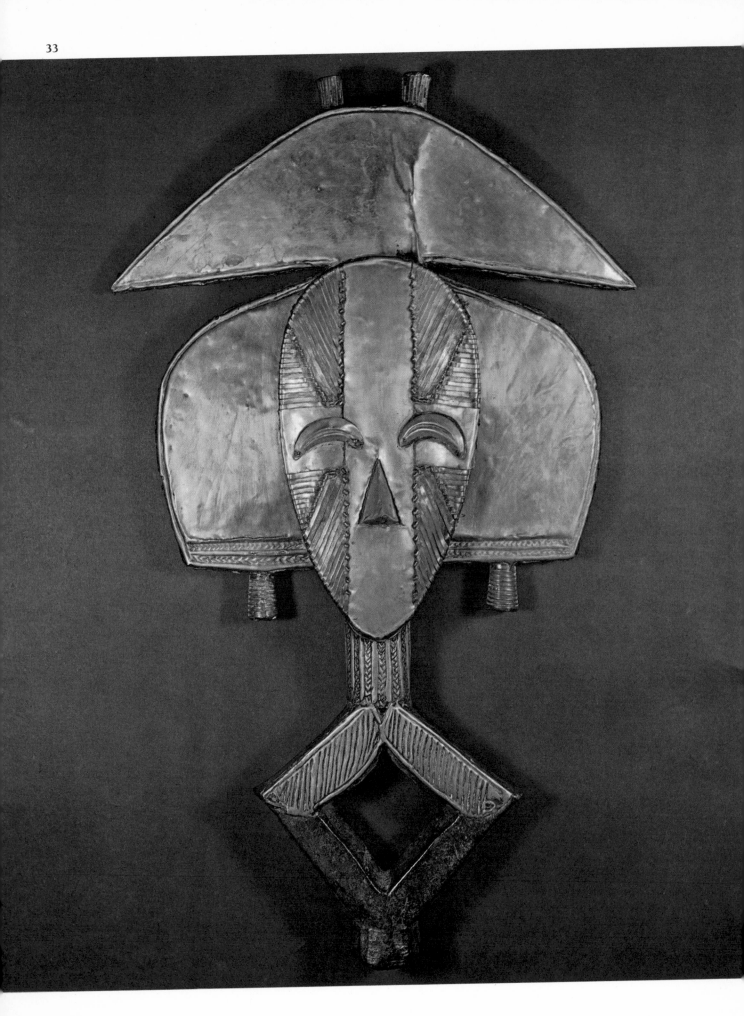

33 Bwiiti head, Bakota, Gabon. British Museum, London. These figures were used to represent ancestors on the reliquaries which were brought out when the particular ancestor was to be consulted at a moment of crisis for the members of his lineage. They were clan ancestors and were ornamented with bronze, symbol of daylight and their capacity to see more clearly what was concerning the lineage members.

34 Kaduna dance mask (front view), Bateke, Zaire. Musée de l'Homme, Paris. See caption to plate 38.

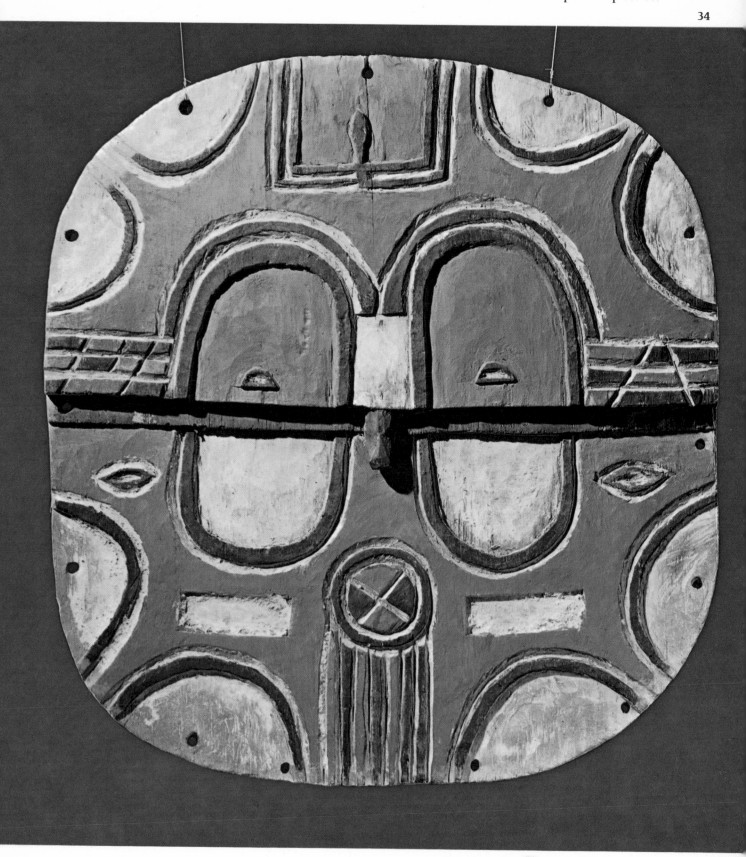

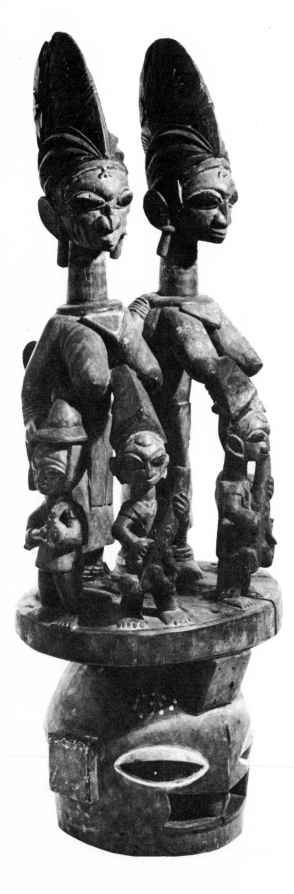

35 Epa mask, Ekiti, Yoruba-speaking people, Nigeria.
In this case the leopard's spots serve to dissolve the
form of the mask when it is moving. They create a
screen and the figures disappear and reappear in a kind
of optical illusion.

Animals and nature

In order to understand African art in its social
context we must also examine two other funda-
mental African characteristics: a strong feeling for
and understanding of animals, and the idea that
man was essentially a creation of nature.

It is particularly the representation of animals
and the masks which brings to our attention the **32**
continuity in the art of the people occupying the
central Sahara eight thousand years ago and the
art of the people in the savannah areas of Central
and Southern Africa which has survived until today,
and the close similarities between the present-day
art of the people of the more southerly savannah
areas on the other side of the equatorial forest. All
these people lived in mixed economies of farming
and hunting and in societies in which a knowledge
of the behaviour of animals was of great importance.
Consequently their social systems and religious
beliefs were closely connected with their under-
standing of animal behaviour and the appearance of
animals, and their art placed a strong emphasis on
forms derived from the appearance of animals,
particularly the masks. It was the understanding
of animals and their life in the savannah and the
forest which inspired the whole of African art and
gave it its unique and outstanding qualities, its
ability to reflect communities who lived in accord-
ance with the demands of the land and the seasons.
It was believed in some African societies that there
was a correspondence between human and animal
characteristics, and some chose as their symbol the
animal they most resembled, and their behaviour
conformed to this symbolic pattern.

The masks from the fringes of the forest and the
savannah areas of the Congo, Masai and Zambezi
rivers illustrated here (plates 34, 37, 38, 39 and 43)
are from peoples who used animal figures in plays
with large casts, the animals often enabling the
audience to recognise the characteristics of particu-
lar clans because certain aspects of the personality
of the clan resembled the features of the animals
behaviour.

Thus the Zebra clan of the Bapede said (according
to Junod): 'Did you not hear the zebras galloping?
They all follow a definite rhythm. If a zebra does
not follow that rhythm he is driven away from the
herd and dies alone.' And: 'We resemble our totem

or spirit. The zebra has got our manners, we have the same way of living.' Junod tells us that the Makhude, Sikororo, Mamatola and Muchiti 'dance the ox', the Maharimani, Phalaora and Thabina 'dance the porcupine', the Khaha, Mphahlele, Mampye, Mamitji and Sahila, 'dance the duyker', and the Masume, Maaba and Mthabe 'dance the elephant'.

'All day Bapedi greet each other with their totemic names, "Good-day Duyker!", "Good-day Elephant!", "Good-day Crocodile!". If anyone should happen to greet another with the wrong animal, the man greeted would answer angrily, "I am not such and such an animal, I am a Duyker, I dance the Duyker!"' (*Bantu Heritage*, J. P. Junod).

Sometimes the animals would be used to portray a particular kind of character in the community such as a chief and then the use of an animal mask would assist the chief's critics to hide behind a disguise.

In many African societies from as far north as the Baganda in Uganda to as far south as the Basotho in Southern Africa the animals were recognisable as characterising certain types of people by well-known conventions, and animal symbolism seems to have had the same implications from west to east as well as from north to south. Thus the bush
42 cow of the Poro society in the Ivory Coast, with its threatening, grunting sounds, can also be found in Malawi, the python linking the men on the throne
51 platform of the Fon of Bamum was also a powerful symbol in Swaziland, and the chameleon of the
36 chief sitting on the bush cow's horns in Nigeria was of equal importance among the Bayaka of Zaire.

A particular feature of the appearance of animals seems to have been emphasised in African masks, the feature which enabled animals to deceive the hunters when stalking them, their power to merge with their environment, in other words their power to effect camouflage. It was this power which was regarded as a powerful symbol of social organisation.

The most important features of the Edo Ekpo society masks in Nigeria were the spots of the leopard. The young men of this society served the king, and their masks symbolised the king's power to adapt himself in the community, to transform himself into a leopard so that he was lost to sight in the vegetation of his environment. In many societies

this power was also symbolised by the chameleon which the Ghanaian writer, Kofi Awoonor, has described in his novel *This Earth My Brother* as 'the changing, never changing'. The chameleon was also the symbol of a cult among the south-eastern group of the Yoruba, the Ijebu, and is referred to in Wole Soyinka's play *The Road* where the lorry driver is

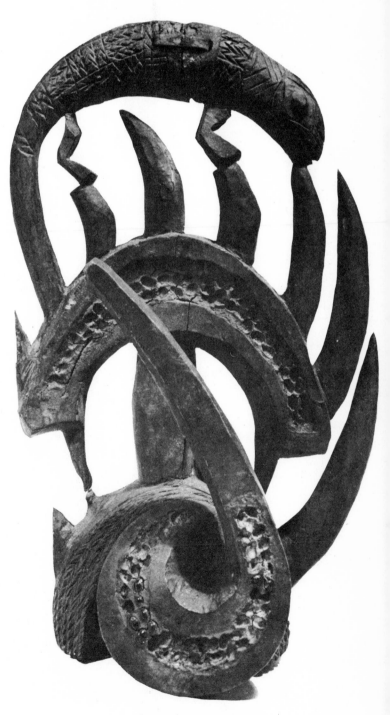

37 Dance mask, Bapende,
Angola. British Museum,
London. A mask of this kind
has been illustrated in plate
47 to show how the use of
optical illusion was employed
as the human counterpart to
animal camouflage. These
masks were used in plays
with huge casts, in which the
animals portray the characters
of the people who belong to
the clans who associate
themselves with those
animals.

38 Kaduna dance mask
(slightly rotated), Bateke,
Zaire. Private collection,
Paris. In this illustration and
plate 34 it is possible to see
how illustrations can be
extremely misleading
concerning the optical effects
of African masks. The line
across the eyes in this mask
is designed to place them out
of alignment as the mask
turns. This is achieved by
setting the top half of the
eyes on an overhanging
ledge; they then become
displaced when the mask is
rotated. If the mask is
photographed from the front
it looks completely flat, and
the line between the eyes is
unexplained.

39 Shene Malula mask of the
Babende society, Bakuba,
Zaire. Von der Heydt
Collection, Rietberg
Museum, Zurich. A young
man's age-group mask
which demonstrates his oath
of secrecy by the band
sealing the mouth.

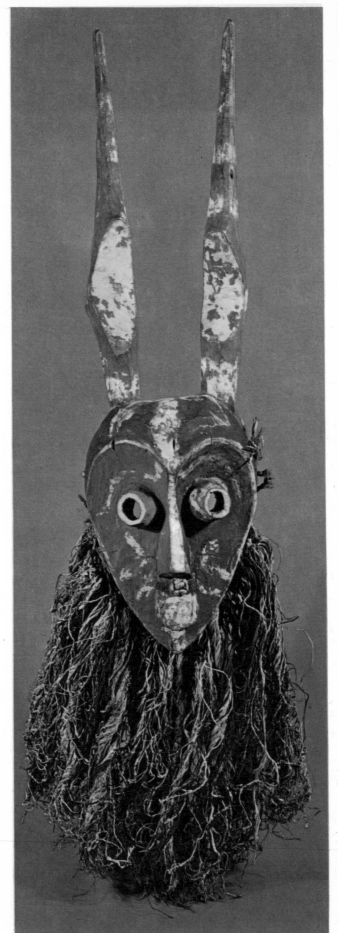

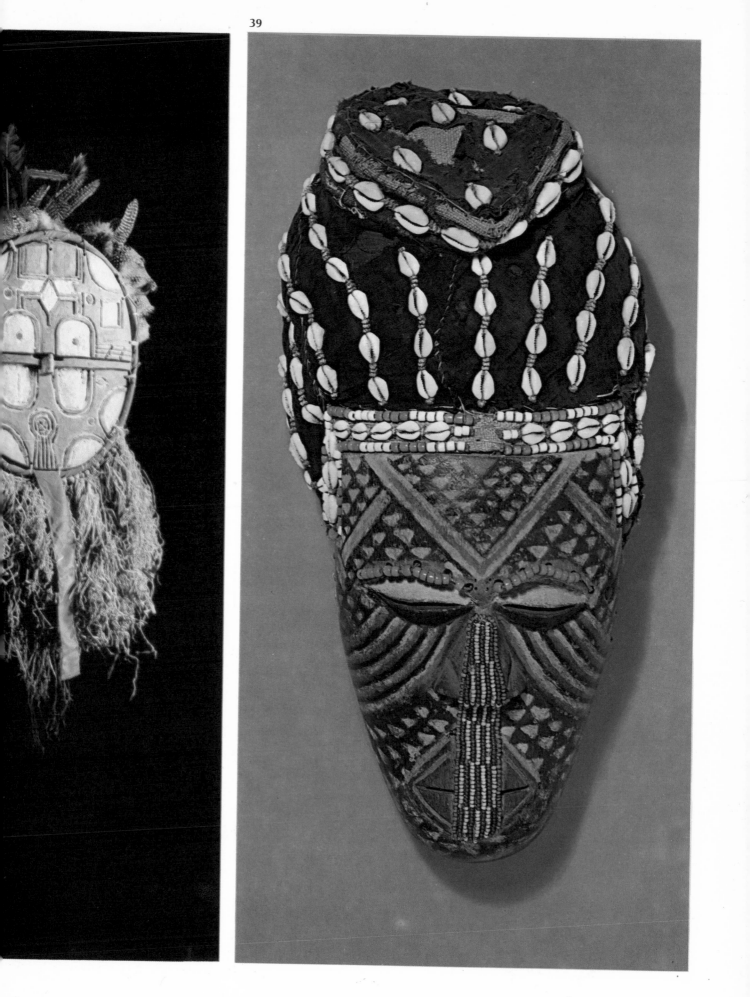

40 Ndzingi masquerader. This masquerader is a comic
figure whose huge head causes him to keep falling over.

recommended 'to become like the road, be like the road itself'.

The men of the Edo Ekpo society in Nigeria expressed that part of the king's personality which was able to adapt itself to the local village community while preserving its own particular royal personality over time and space. This gave them a dual role in the society and the duality was expressed by the leopard spots on the masks worn in their society's plays.

The spots of animals as a symbol of adaptability were used in many other masquerades of the African communities. They were used, for example, as a means of optical transformation in the Epa masks of 35

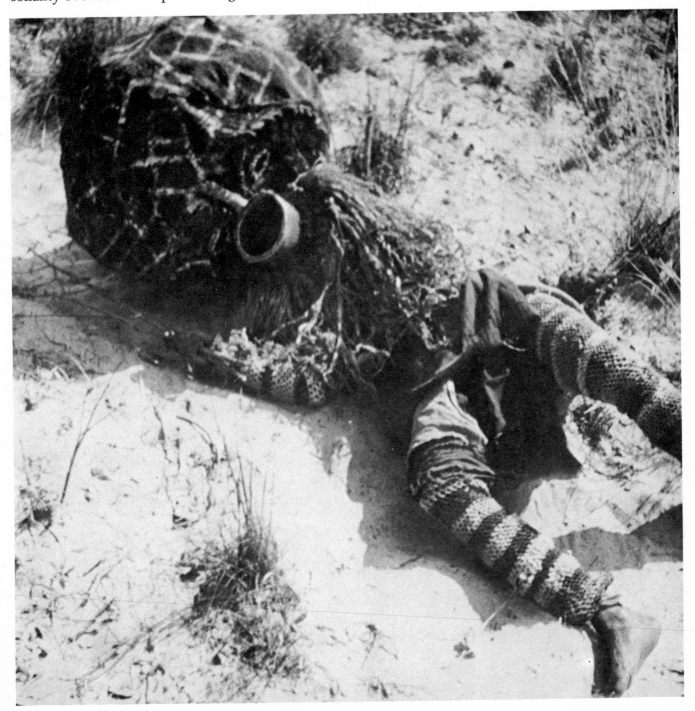

the northern groups of the Yorubas, the Ekiti. The masks had an elaborate superstructure of figures but the spots formed a veil when the masks were swaying from side to side, and the figures only became clearly visible when the masks were standing still.

The masks of the society of the Bayaka of the

Congo spun round first in one direction and then in the other, and the projections around the face became a series of hoops or rotating satellites, and the features of the face were only discernible when they came to rest. 48

The string costumes of the masked figures of the Lunda group of peoples in Southern Africa (in-

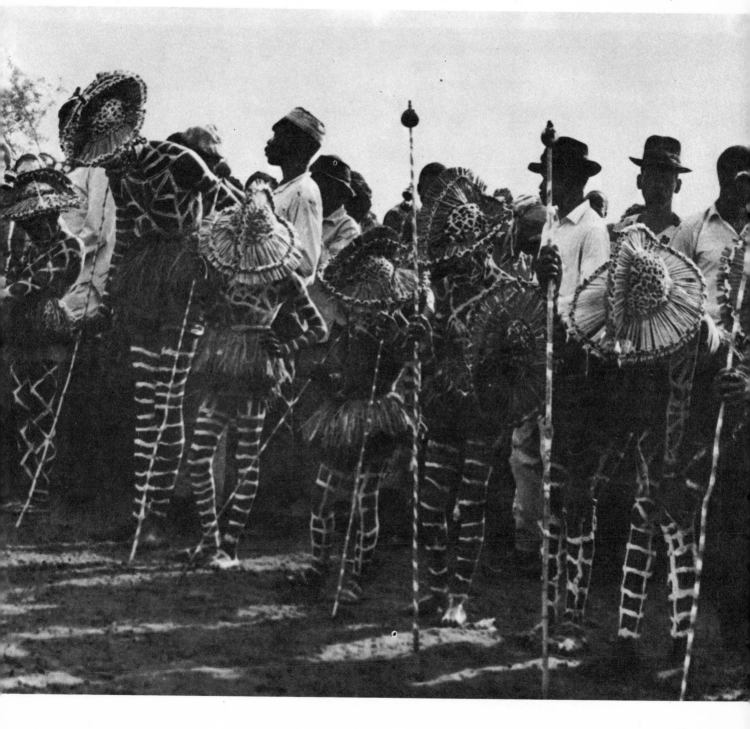

42 Masolo masquerade animal of the Poro society, Senufo, Ivory Coast. Representing a bush cow, the tent-like structure hides two men who make frightening sounds (deep grunts) with the help of a drum and a stick. The mask is kept hidden in a secret place, and no woman or child comes in sight of it when it is in use.

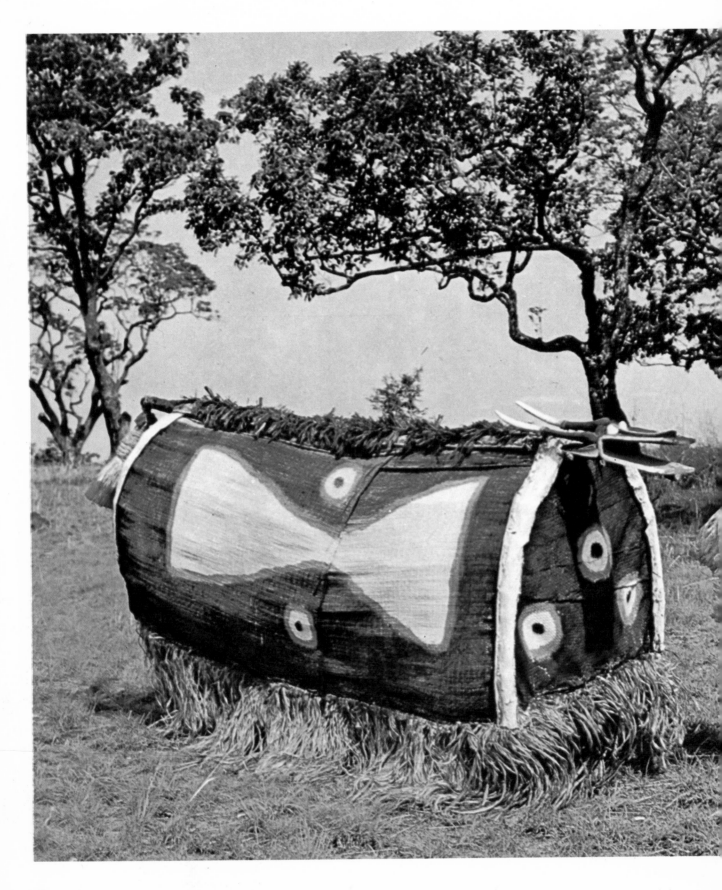

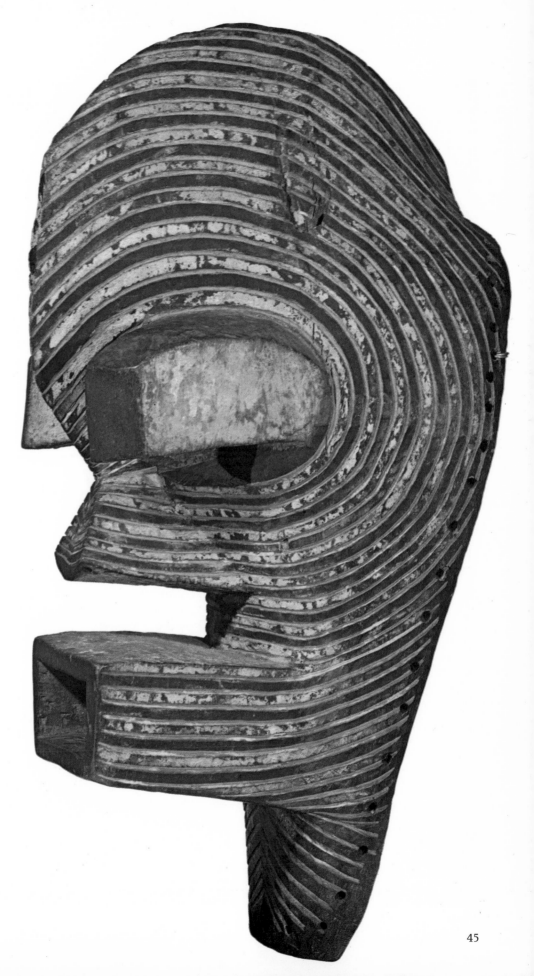

43 Kalebue mask, Basonge, Zaire. Pinto Collection, Paris. This is a mask which emerges from a fire. Its red, incised circles and jutting eyes and mouth keep it concealed until it leaps at the spectators.

44 Bulls' heads engraved on a rock, Tassili n'Ajjer, Sahara, Algeria. The bulls in this engraving (made on a sandstone rock face by drilling a series of holes and smoothing them over with a stick and wet sand by a method of which no one nowadays can discover the secret and which goes back as far as nine thousand years) have the deformed horn which the peoples of the southern part of the Sudanese Republic still produce in some of their cattle at the present day.

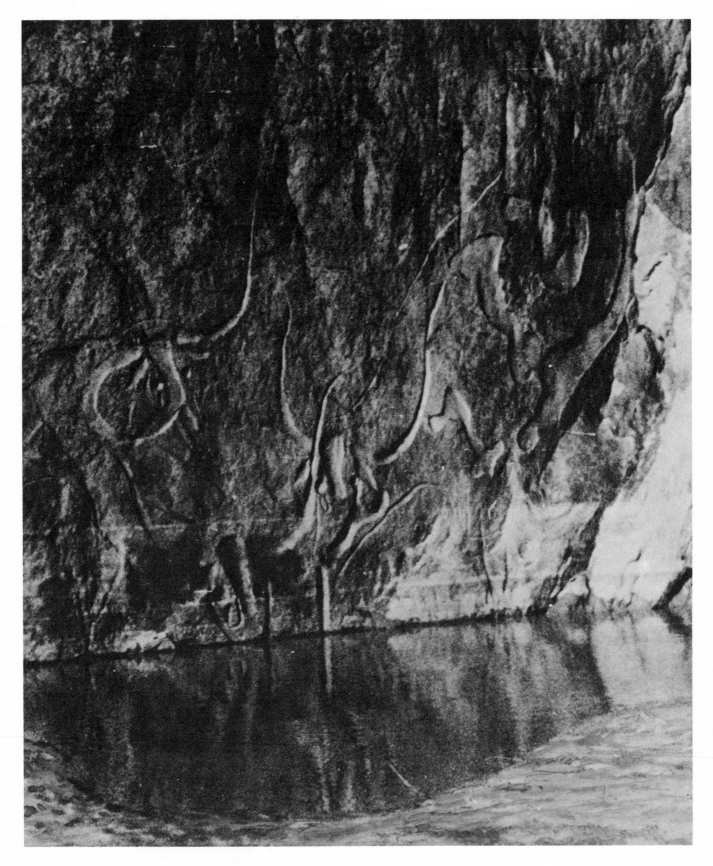

45 Ekine society mask, Kalabari Ijo, Nigeria. This mask represents a water-spirit. The protuberances on top are probably the outlets for a Western ship's ventilator. The water-spirits from the sea are the most difficult to control and can only be brought into the society by people who understand them.

46 Ekpo society mask, Ibibio, Nigeria. The Ekpo society is common to many other people in southern Nigeria as well as the Edo-speaking people of Benin. This Ibibio Ekpo mask can be used to carry out the sanctions for committing criminal offences and represents a dreaded disease.

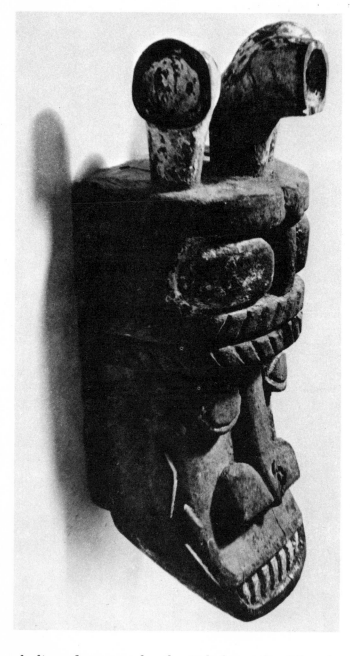

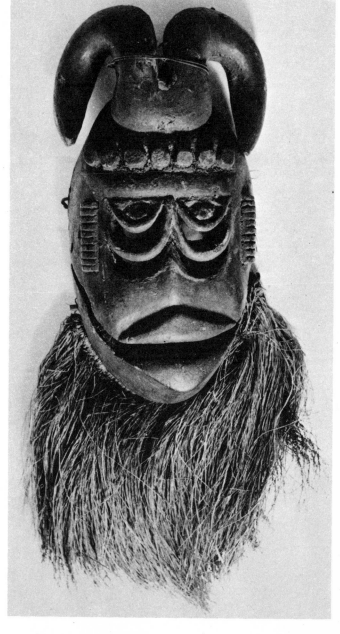

cluding, for example, the Tchokwe, the Mbwela
41 and the Wiko) were covered in a pattern of white lines so that they were lost in the orchard bush of the savannah or appeared as skeletons in the dark.
47 The hidden forms of the masks of the Dan appeared convex when they were in shadow. This effect is similar to that created in a seven-thousand-year-old
44 Saharan rock engraving in which the head of a bull drinking at the level of a stream appears to be modelled in relief when in fact it is composed of forms hollowed into the rock face.

These people were thus deeply concerned with the behaviour of animals in their environment and with the idea that man could change himself into an animal and vice versa; and in expressing this concern their art demonstrated an accurate perception of the optical effects of animal camouflage. Closely bound up with this attitude was the belief that man lived his life in harmony with the seasons and the forces of nature, and that he had a natural development in being born from the earth and returning to it when he died.

47 Mask representing an animal totem of a clan, Bapende, People's Republic of the Congo. British Museum, London. In many African masks visual tricks are played with the object of confusing the spectators of the masquerade. Here the shadows in the hollows break up the whole form of the mask when it appears in a dim light. This, combined with a deliberate displacement of the painted pattern, disguises its real form. This effect of camouflage is achieved so that the spectators do not know precisely where the mask is.

48 Age-group mask, Bayaka, Zaire. Collection Eduard von der Heydt, Rietberg Museum, Zurich. The whole form of this mask is adapted to a gyrating movement which conceals the features until the mask comes to a standstill.

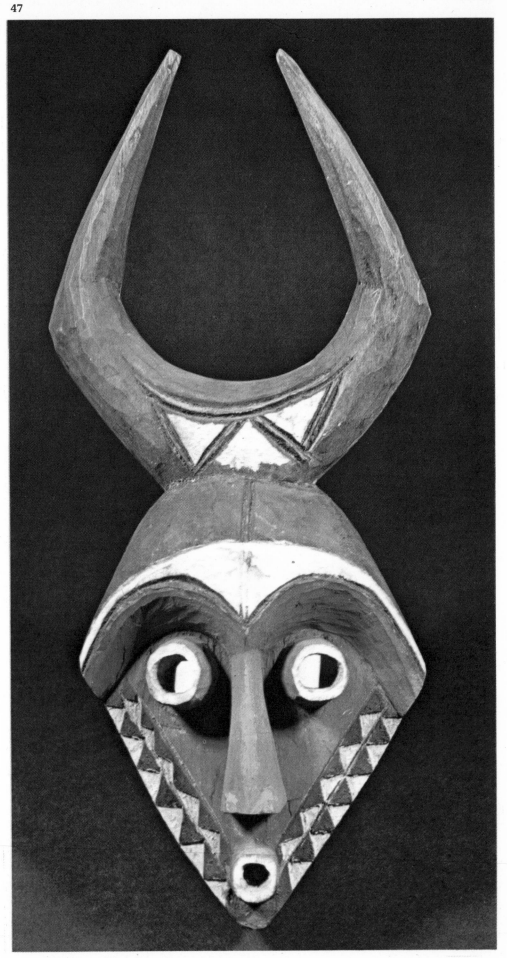

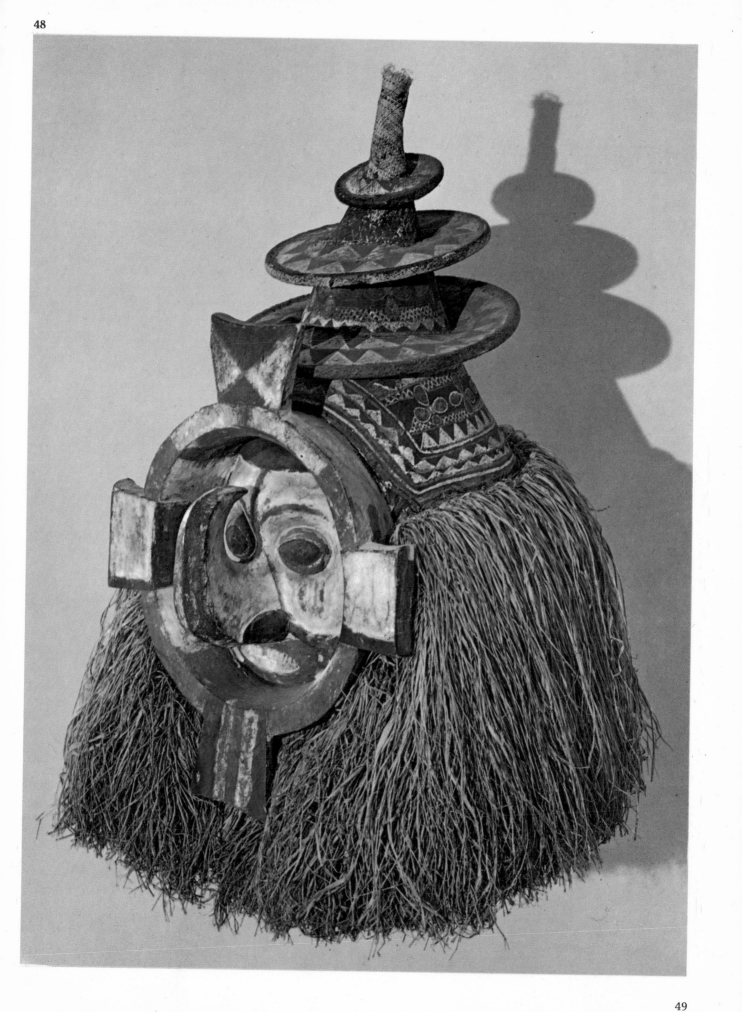

49 *Ikenga*, Ibo, Onitsha, Nigeria. This is the carved stick which a man was given by his age-group when he assumed adult responsibilities. It also carried the horns of the animals which taught him the secrets of the bush, helping him to be a hunter.

rhythms of life was to understand the irrational element in human existence in the world. This nineteenth-century identification of African rhythmic understanding and an intuitive or irrational direct communication with nature has been enlarged upon in this century by African apologists such as the poet, Leopold Sèdar Senghor (now President of Senegal), with his concept of 'negritude' in which the African becomes essentially an irrational creature, who has a different kind of understanding of the universe with his non-Western rejection of scientific logic.

In fact on closer examination the African concept of rhythm turns out to have been just as scientific and logical as any Western form of psychology. The idea that a human being expressed in his art his relationships to the particular configuration of forces in his environment was to be found in the emphasis placed on the rhythm of a man's movements which were thought to express his particular personality and his particular way of moving in his society, his particular existence in that society.

It was important in such societies for a man or woman to remember into which clan they were born because to know the name of their clan was to understand their personality. They might not marry members of their own clan in case this personality should become exaggerated. It did not matter that kings married within their own clan because there were, as we have seen, ritual processes for controlling the exaggeration of their own personalities. The animal totem of African clans therefore expressed the fact that a child with a particular parentage took on some of the personality of its parents and expressed that personality in its movements, of which a consequence was the rhythms with which it danced. It was also accepted that there were elements in an individual's particular personality which conflicted with the personality of its parents and the personalities of their clans. This meant that the previous rhythms and their clan's rhythms expressed a particular adaptation of their movements to their environment, but when the environment changed (and some individuals were hypersensitive to environmental changes and to the conflicts they produced in the rhythm of their personalities) these individuals became priests or priestesses.

Rhythm

It is not surprising that rhythm played such an important part in the art of sculpture in wood when we consider its importance in other aspects of African life and art, for example, in music and the dance and in ideas held about the nature of human society. During the nineteenth century, European observers were prone to regard rhythm as a characteristic of the 'primitive'. To understand the

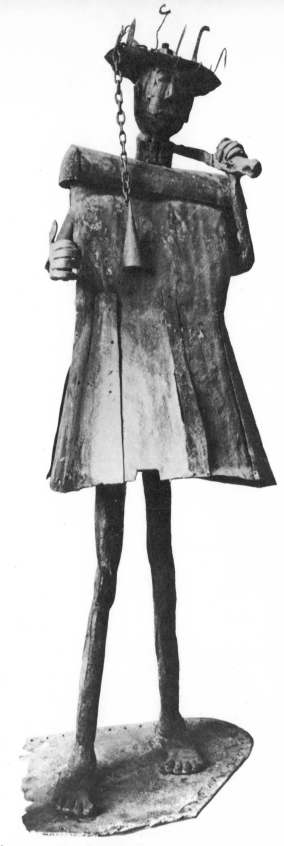

50 Iron statue, Yoruba, Dahomey. Musée de l'Homme, Paris. A statue of Ogun, god of iron and god of war. Iron statues are rare in Africa although there are many examples of birds in iron, for use on chiefs' or elders' staffs. Birds are represented here on Ogun's head, thus connecting him with the earth. He has a raffish appearance in this sculpture which accords well with his reputation as a swashbuckling old soldier.

For the significance of what it means in an African society to dance in or out of a particular rhythm, we can read the play *Anowa* by the Ghanaian playwright, Ama Ata Aidoo. The heroine of the play is a young woman who refuses to marry the man of her parents' choice and insists on marrying a man of her own choice. Her father says that her rhythms have always been out of step with those of her clan and that therefore she should have been apprenticed to be a priestess, a common role for those who habitually did not conform in many African societies. The old man who is the chorus of the play, together with an old woman, relates: 'They say from a very small age, she had the hot eyes and nimble feet of one born to dance for the gods.'

In some African societies such individuals could join special cults which formed societies for entertainment, which enacted in their plays forms of innovation which were necessary in the community to make its adaptation to a new environment possible. A cult of this nature was the Ekine society of the Ijo Kalabari in the delta area of the river Niger in Nigeria. An initiate to this society was one who had opted out of the normal roles carrying status in the community and had elected to wear the masks of the most fearsome water-spirits who brought the principle of innovation into that community. However, if he did not understand the clan rhythms at the same time as he introduced the innovative masks, it showed that he was not one who understood the tradition of the society and was therefore not fit to introduce innovative movements. This was expressed when the initiate first danced with a mask in the community. The drummer beat out the rhythms of the drum-calls of the ancestors and tried to confuse the dancing initiate by disguising them with cross-rhythms. Should the initiate dance the wrong rhythms he failed a test of his understanding of the community's established rhythms and would be shamed and disgraced. He might even be beaten to death.

Cults and societies

An individual therefore could join the cult which suited his personality (in this particular case as an entertainer or innovator). In most societies there were cults to which all individuals might belong during the natural course of their life according to their sex, and cults to which they might belong as members of a particular lineage or clan. Young men and women belonged to their age-groups' initiation societies, from which certain non-conforming individuals might split off to form separate entertainment cults. Adults would join societies for mutual help in hunting, farming or marketing. Elders would join their own age-group societies, which would be concerned with the settlement of villages

51 Throne, Bamum, Cameroon. Museum für Völkerkunde, Berlin-Dahlem. The Bamileke peoples of northern Cameroon make the most elaborately beaded sculpture in Africa. The patterns of the beads help to hide the form. They cause the row of figures at the bottom, for example, to turn into a snake.

52 Ancestral screen, Kalabari Ijo, Nigeria. British Museum, London. The Kalabari Ijo have to understand the ways of the creeks and the sea. The spirit which guarded this ancestor had the understanding of the sea of European seamen, hence their type of boat. He also guarded the head containing his second soul.

53 Female figure, Bena Lulua, Zaire. Museum für Völkerkunde, Munich. Covered in red earth, symbol of fertility, this figure clearly demonstrates the cylindrical series of forms that are produced by turning the wood to the strokes of an adze.

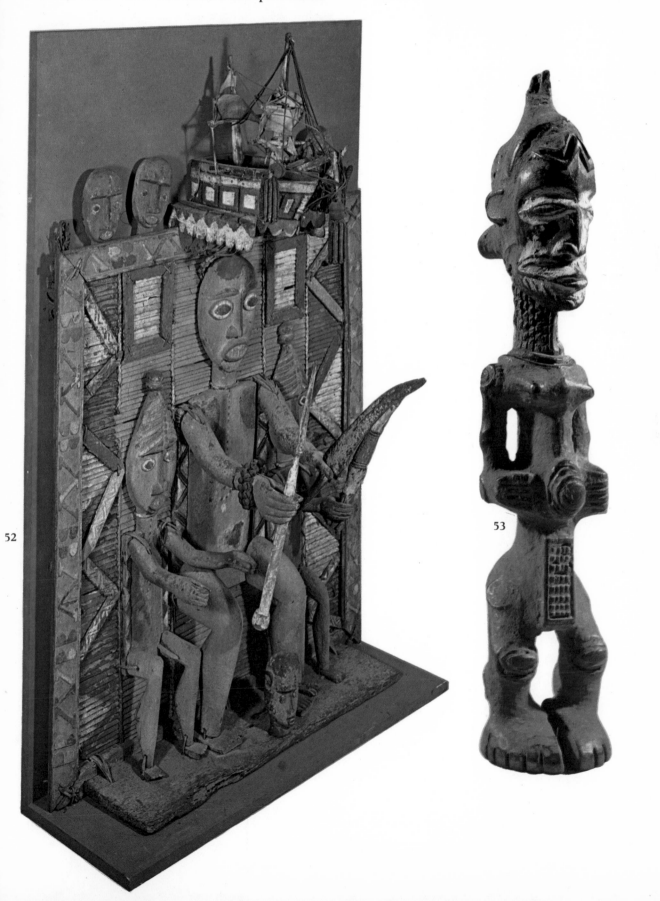

52

53

53

and territorial affairs. Priests and priestesses would serve in the cults of the local gods. There was a form of cult which was designed for people who had certain personality traits, and allowed individuals the opportunity to express those particular characteristics. These cults were particularly prevalent among the people who spoke the Kwa group of languages in West Africa, the Yorubas of Nigeria, the Fon of Dahomey, and the Ewe of Togo and Ghana, and they are the cults which have been exported in a modified form to America, the cults of Voodoo in Haiti, of Bembe in Cuba, and of Candomblé in Brazil. They also seem to have existed in the people belonging to the Luba empire in southern Central Africa, but not as much is known about them as the cults of West Africa.

Among the Yoruba a diviner would decide to which cult a child should belong soon after it was born. If it was clear that the diviner had made a mistake the individual could go back to him or to another diviner to find out which cult his personality did fit. A good example of a cult which fitted a particular kind of personality was that of Sango. Sango personalities were sometimes arrogant and overbearing and sometimes withdrawn. The myth of the cult expressed this personality. The king, Sango, had two generals who were always fighting with one another so that the people called on the king to stop the unnecessary bloodshed. He made one of the generals king of another town and sent the other off to attack him hoping that one would kill the other. Unfortunately the one who had become king responded by going to sleep when he was attacked, and was captured and taken back prisoner to the king by the other general. When the general who had been taken prisoner woke up, the two resumed their fighting and the king sommitted suicide, but was made a god.

Every year devotees of the cult of Sango enacted this myth in their festivals and were given the opportunity to expose the two sides of their personality. When they acted in a bombastic way and ended by running away from real confrontations or difficulties in public it was said that they belonged to the cult of Sango, and so their idiosyncrasies were given due allowance. It might be suggested that the reason for the prevalence of the cult of Sango in the English-speaking Caribbean

was that the Sango personality expressed the character of the slave, with his violent resentment, his being compelled to conform, and his ultimate wish to commit suicide so that his spirit could return to the land of its origins.

In the same way the cult of Ogun, the god of iron and of hunting, was concerned with innovation and change; he was also a god closely linked with the earth where the ore is found. Consequently iron sculpture was not normally linked with rulers. It did not carry the idea of permanence and the brightness of day and the sun which was associated with kingship; instead it was the metal which helped a society to adapt to new circumstances. We should not therefore be surprised that its god, Ogun, was followed by the soldiers who took part in the first black revolution, in Haiti in the early years of the nineteenth century.

Generally the special cults fitted in with the overall pattern of individuals' lives, which as we have seen were concerned with the opposition between conforming to a social pattern and the need for change. The hunter was often the agent of change; he came from the earth and understood the earth and the creatures it produced, and he was therefore represented by a cult of iron. During the festivals of Ogun the devotees were also painted with white clay because clay was a symbol of the earth, being produced by the earth in the same way as iron.

Existentialism

We have suggested that the sun and moon in African art derive from a division between the sky king and the queen mother, who represents the local earth and the local inhabitation. The myth that the king's gods are in the sky while the gods of the indigenous people are those of the earth is found in many other parts of the world, and as far afield from Africa as China and Japan. However it had a particular significance in African thought about the universe, which was much more like modern Western existentialist thought. It said that man's view of the world was determined by his surroundings, and that as he grew up his horizons got wider, but that with the widening horizons he took on more and more responsibilities to the social group in which he lived. This was expressed by the

collection of objects in a man's personal shrine, for
49 example by the *ikenga* figure which an Ibo man
obtained from his age-group when he achieved the
full status of adulthood. Later, when he became
the senior elder, he took on the responsibility of
looking after the shrine of his father, which con-
tained his father's *ikenga* and those of the grand-
fathers it was still important to remember. The chief
or senior elder in the village had to offer sacrifices
at the shrine containing the figures of important
village ancestors, and the clan head had to do the
same at the shrine of the ancestors of the clan. The
king looked after the shrines of the founding
ancestors of the whole people.

The ceremonies concerned with the propitiation
of all these ancestors emphasised the fact that they
had changed their descendants' outlook and given
them their characteristic personalities. The found-
ing heroes, the heroic ancestors of each group,
became the gods, and the gods of each were a kind
of symbolic manifestation of that group's person-
ality, an exaggeration of the characteristic features
of their personality created by their past and their
environment. They acted out what the world was
like for the members of each particular group.

This existentialist way of thinking also helped to
explain why most African societies south of the
Sahara resisted the introduction of writing. For

55 Baluba figure, Zaire. British Museum, London. This figure supports the seat of a stool which could have belonged to a chief or a queen mother. The stool was an important symbol of chieftainship, and in some societies the chief was buried sitting on a stool.

56 Bronze plaque, Benin, Nigeria. British Museum, London. The king looks as if he has been placed on the stool because his feet must not touch the earth. He was allowed a permanent and public display of bronze because his art expressed the perpetuity of his lineage as rulers.

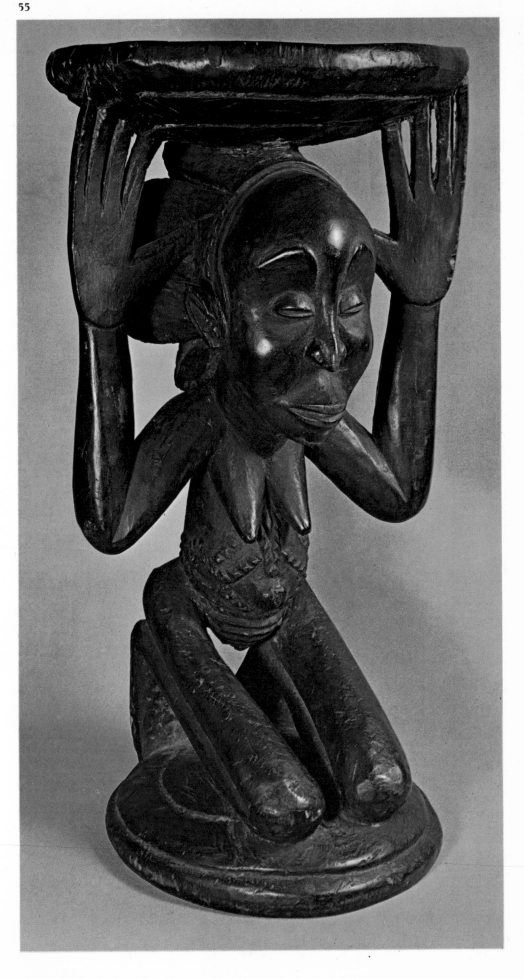

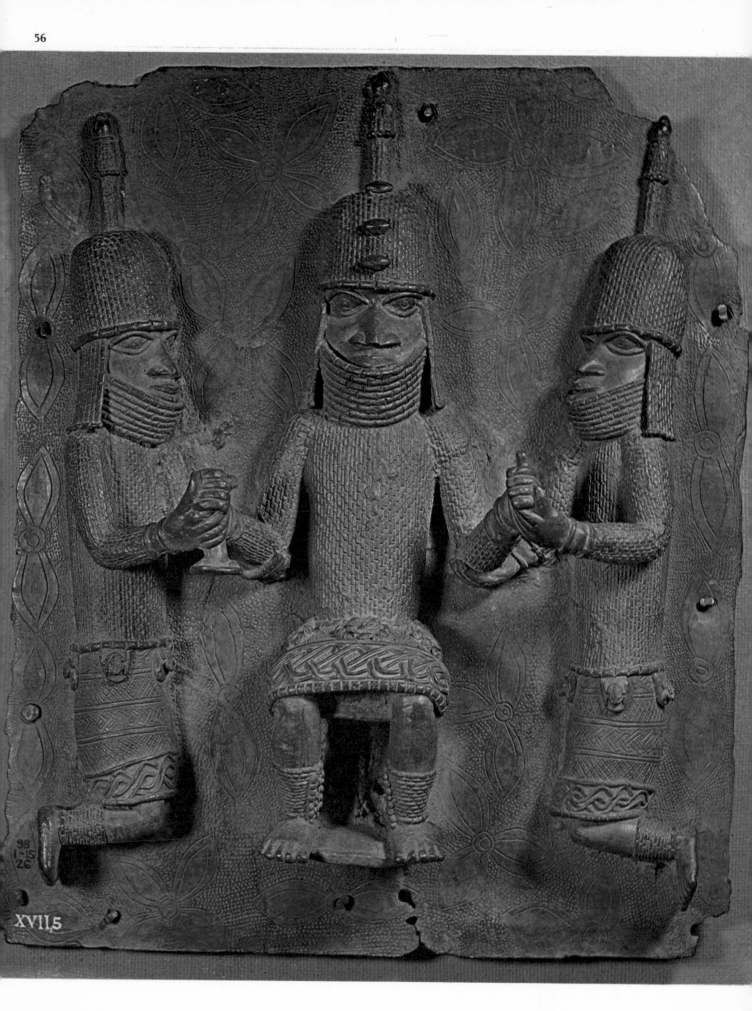

example, the Ashanti in Ghana employed Manding scribes from farther west, adherents to Islam, to write the Ashanti language with an Arabic script to convey messages from one court to another, but would not learn to read and write themselves. The myths and history of each clan or social group were private to that clan or group and were not for common distribution. If they were too widely known they would draw attention to past disagreements with other groups, or features of a particular group's personality which made them unacceptable to other groups. As a result strangers were often people to be suspicious of, and strangers in Ibo villages in Nigeria had to paint themselves white in order to declare themselves to be strangers so that they would not be attacked. At the same time, while the myths and stories could not be related except in the particular clan, household or village to which they belonged, they had to be changed to fit each new generation, and therefore it was important they should not be written down.

In exactly the same way the older masks and carvings had to be seen to be disappearing by each new generation and to be eaten by ants, the agents of the earth, the source of regeneration. This process was itself symbolised by the Ibo people of Owerri in Nigeria, when some chosen members of the society constructed Mbari houses. These houses with elaborate scenes constructed in mud sculpture were constructed at times of crisis, such as famine or plague, on the instructions of diviners who said that a god was displeased and needed the attention of the community. The making of the house was supervised by a master-sculptor who carved a representation of all the gods and spirits and their importance in people's daily lives. The period of construction might last three to five years. When the house was complete a big celebration was held with feasting and dancing which might last a week. Then the house was left to decay and fall down, and none of the figures were repaired after they had been damaged by the weather. The house took as long to decay and fall down as it did to build.

The Mbari house was a kind of external symbol of all the hopes and fears of the community as it existed at a particular time. It had to decay because the community had to change and acquire new hopes and fears. Next to the earth goddess Ala (in the illustration) is a European riding a motor cycle. In other Mbari houses, Europeans were shown emerging from the ground because that is where, according to popular myth, they first came from. Perhaps this was because they had the whiteness of the clay with which people painted themselves at festivals or to declare themselves strangers and which was taken from the ground. A new goddess has been found in recent Mbari houses, Mamy wata, a young woman dressed in fine clothes who controls snakes, seeming to symbolise how riches come to young women who encourage sexual desires. Mbari houses also contained explicit sexual scenes which normally the society might not talk of. Thus the Mbari house showed the Owerri Ibo-speaker all the uniqueness of his particular world.

Similar existentialist characteristics of African thinking about the world are displayed by Ezeulu, the priest of a village, in Chinua Achebe's *Arrow of God*. Ezeulu's role is very similar to that of the king of the Onitsha, a very extensive town in eastern Nigeria, and he explains that he is a kind of substitute for a king. 'Long long ago there had been a fifth title in Umuaro—the title of king. But the conditions for its attainment had been so severe that no one had ever taken it, one of the conditions being that the man aspiring to be king must first pay the debts of every man and woman in Umuaro.' When Ezeulu is forced to stay at the headquarters of the British District Commissioner because he refuses to accept the position of Warrant Chief, he tries to look for the new moon because it is his job to tell the village when the new yams should be harvested and they may not be harvested until he sees the new moon. He cannot see the moon and he says that it is because the sky of the District Commissioner's headquarters is not his sky. 'Why should the sky of Okperi be familiar to him? Every land had its own sky; it was as it should be.' Ezeulu fails to see the new moon from the District Headquarters, and when he gets back to see his own village he refuses to announce that the yam-harvesting time should begin. The villagers begin to get hungry and to eat their seed yams. Ezeulu ceases to impose the regulations of his own village's sky because he has not been present to experience them, and so the villagers end by rejecting him and his particular deity.

AFRICAN SOCIETY
and the arts

Permanence and impermanence

There were, as we have seen, special cults for personalities who demanded innovation and change, and it was accepted that each new generation had to develop special skills to overcome the challenge of a changing environment. Consequently some of their members had to be allowed special means of innovation and if necessary of rebellion against the order imposed by their elders. This is why satire of previous generations and a theatre which invented new personalities which reflected special forms of change were important features of old African art. The use of forms of expression based on a close observation of animals, and their behaviour in their environment, was a constant feature of the art for eight thousand years and explains its long continuity, but the adaptation of these forms to the poetry and theatre of constantly changing conditions explains their variety and vivacity. The necessity for adaptation also explains why the art was made of transient materials and why it was kept out of sight until it was needed in a theatrical expression of what was of most contemporary and immediate concern. It explains why the visual art should never be considered apart from the theatre and music which accompanied it. Sometimes kings and courts were to be found which strove to impose a permanent order on society and employed craftsmen to make sculpture and decorations which would last and perpetuate that order, but their art was really a very small proportion of what was actually created – the millions of masks and figures in wood and even less durable materials such as leaves and fibres which were continually being made and disappearing every few years.

The pieces illustrated in this book have been chosen in order to illustrate the contrast between those which were deliberately made to be durable and those which were made to perish and disappear when not in actual use.

For example, the Bwa of the southern region of the Upper Volta made masquerade costumes of liana **59,60** bark, karité leaves and dried grasses, which had to be remade every year, but the bronze-workers of the Oba of Benin made plaques in the seventeenth **56** century which we know to have been displayed then and to have remained on the walls of the Oba's palace for two hundred years (they were described by the Dutch sea-captain David Van Nyendael in 1702, and were taken from Benin and sold to museums in Europe after the Benin expedition of 1897). The Bwa leaf masks were made for a ceremony in which the young initiates struggled with the masked elders and symbolically defeated them, 'killing' their fathers, but the Benin bronzes were made for an Edo king who celebrated his hereditary right to rule. (However the Ekpo masks of the initiation societies in Edo villages institutionalised the young men's opposition to the rule of the elders with the support of the king; and we have seen that each member of such a society was in an ambivalent position, both supporting and opposing centralised authority at the same time.)

The opposition between art made of transient materials and generally kept invisible and art made of durable materials and brought to people's attention over continuous periods was paralleled in the institutions of African society; in the cults of ancestors and the cults of the spirits of nature belonging to the initiation societies. (Where courts had developed they were usually the courts of rulers who had increased the power and duration of their own ancestral cults.)

In many African societies the oldest man of a family kept a shrine in the family compound where **52** the spirits of the ancestors were propitiated and could be invited to be present on important family occasions, for example, at births, marriages and deaths. The ancestors were represented by carved images on sticks, which were said (among the Edo

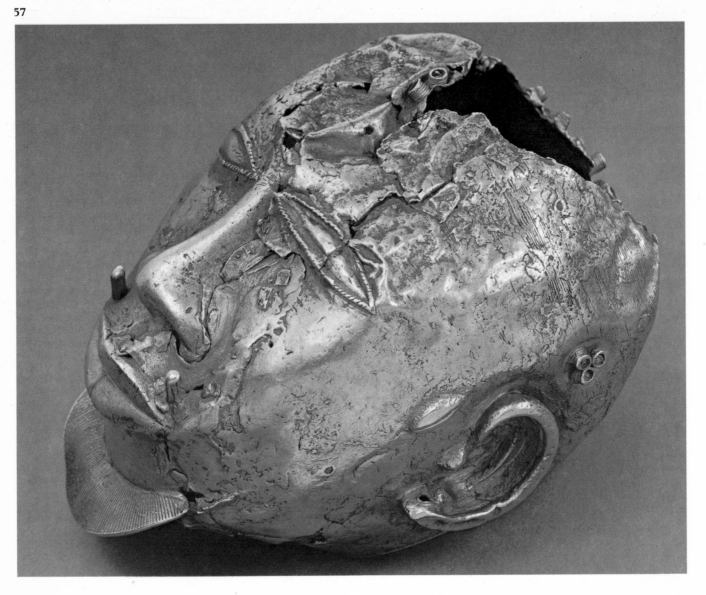

of Benin in Nigeria, for example) to be 'planted' in the shrine after the elder had been properly buried. However ancestors were supposed to go back to the earth and to gradually become part again of the substance from which life created natural beings and plants. Eventually therefore their carved representation would decay and be eaten by ants and their descendants would cease to bring them sacrifices.

As the sticks or images decayed they were forgotten. The Mumuye ancestor figure from northern Nigeria in plate 61 can be seen in such a state of decay; it was also represented as a phallic symbol so that it symbolised life returning to the source of life itself, that is the earth. The family therefore remembered its immediate ancestors for three or four generations and thus its ancestral figures were usually made of soft wood and allowed to disintegrate, but the ancestors of the kings were represented by figures made of very hard wood and carefully preserved. Alternatively, kings kept

the heads of their ancestors preserved in bronze and wore mask-like heads hanging at their waists **57,64** at their own installation. The head was thought to be the seat of a man's own individual spirit or personality and its representation in bronze indicated its permanence as a centre of power. A story to explain the ending of bronze founding in Ife, of the Nigerian Yoruba people, seems to symbolise the significance of bronze. It is said that an Oni of Ife had all the bronze-workers executed after the palace household of his predecessors had tried to prolong the reign of the previous king when he died by dressing up his bronze head in a dark corner of the palace and pretending he was still alive.

The bronzes of the Ogboni society of the Yoruba people were hidden away or kept in the dark. They represented a force too powerful to look at in the light. The Ijo Kalabari bronzes of Tenema in the Niger delta were supposed to have come from far away and to appear by themselves for a very short period and then to disappear.

57 Gold mask, Ashanti, Ghana. Wallace Collection, London. Kings all over West Africa wore masks of their heads on special occasions. Usually they were made of bronze to show that the king's second soul had an unusual permanence, and had the shining brightness of the sky. Gold expressed this even more clearly.

58 Mask, Marka, Mali. Ethnographical Collection, Zurich University.

Most of the art made in permanent materials, such as gold, bronze and hard wood was found in the centralised kingdoms in which the ruler had to express the fact that he and his ancestors had imposed a particular kind of order on the society for the good of all the people in it. It was admitted that the order that the king had imposed and that his subjects had accepted was a very particular and individual one which varied with the circumstances of each region. However it was also the order imposed by this particular clan, the royal clan, and the fact that this was an alien order which the people had nevertheless accepted was usually symbolised by the myth to which we have already referred, that the members of the royal clan were sent into the society from outside or were conquering invaders.

We can see here, once more, the overall dichotomy or dualism illustrated both by the type of art used and by the materials out of which it was made. Thus there was royal statuary and ancestor figures on the one hand and masks and fertility figures on the other. Royal statuary was made of lasting and durable materials sometimes publicly displayed; ancestor figures were made of more transient materials so that they disappeared rapidly and were less publicly displayed; the same applied to the fertility figures, while masks were made of perishable materials and made fleeting appearances in public.

The kings in Africa who used durable materials in their art—gold, bronze, iron—and who made a public display of that art were not found as frequently as we might suppose. We get a distorted impression of their widespread existence because the art that has been preserved is naturally the most permanent. At the same time Western culture has placed a premium on what can be preserved and displayed so that the metal sculpture of Africa is the kind that has been mostly highly prized in museum collections. Anything that involves a long and technically difficult process in its manufacture has also been more highly regarded by Western culture. It must be pointed out, however, that the 75 production of sculpture in soft wood by African sculptors was a highly skilled process and one

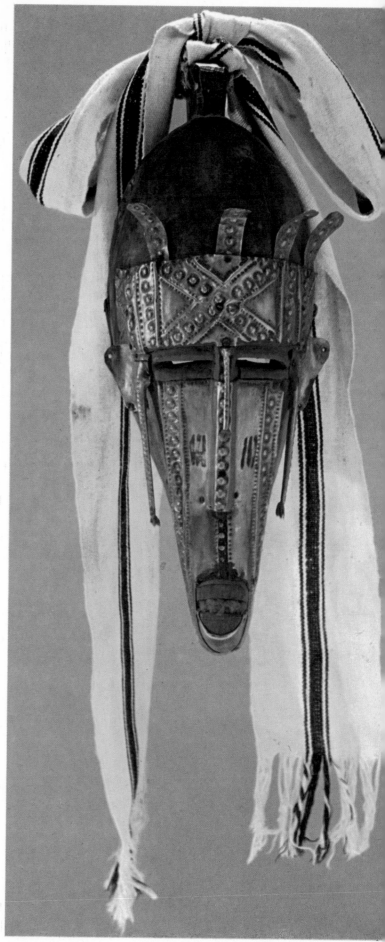

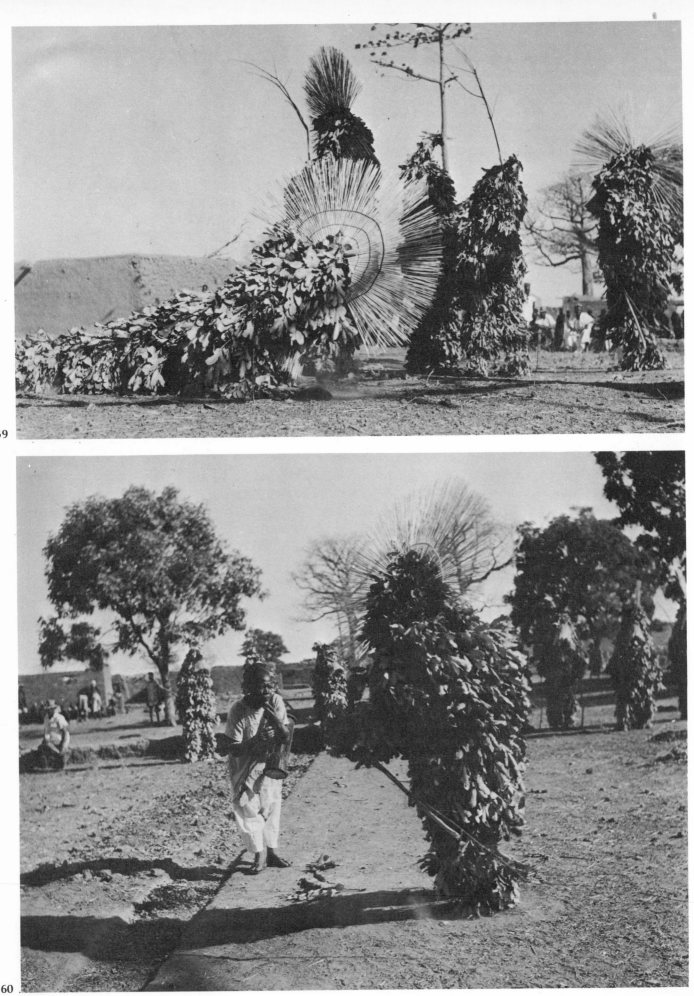

59

60

62

59 Mask of leaves, Bwa, Upper Volta. This masquerader is a youth who has gone into the bush to acquire its secrets to use in his encounter with the elders (see plate 78). The mask is a symbol of a new generation, and vanquishes the elder's mask in a mock fight.

60 Mask of leaves, Bwa, Upper Volta. The drummer brings the mask into human society because the drum rhythms are a sign that the mask is submitting to social organisation.

61 Ancestor figure, Mumuye, Nigeria. The ancestor figure was left to be eaten by ants, but was represented also as a phallus to symbolise its regeneration. The elder has fulfilled his responsibilities in the community and is not supposed to cling to them after death. However he has to come back to assume new ones.

which probably involved a longer and more difficult training than casting in bronze. Bronze-casting requires the passing on of acquired secrets in the use of the metal, but African wood sculpture required a skill in movements of the hand which it took many years to learn and which could only be passed on by a master-sculptor. The essential feature of African wood sculpture was its rhythmic creation. It was made with the adze to begin with, and the shape of the wood could only be obtained by a succession of rhythmic strokes of the adze while the trunk of the tree was being turned. Recordings which have been made of the blows of the adze indicate a rhythm which is very similar to the beating of a drum.

We have seen (page 22) how the earth was regarded as the source of the life-force, a principle of constant innovation and renewal. The sky sought to take the products of this life-force and fix them into a pattern. The sky imposed repetition and regulation. The king, for example, who represented the spirits of the sky, had to have his drums beaten at dawn to announce the advent of a new day, and he had to say when the crops were to be harvested. However, the earth produced forms of life which did not fit the established pattern. Consequently, if we look at the art of an earth cult such as the Ogboni society of the Yorubas of Nigeria, we see how the life-force is expressed. The sculpture seems to contain a force straining to get out and produce a completely new manifestation.

The life-force was also expressed in sculpture by the insistence that rhythm played a part in its production, and the adherence to methods which required a rhythm as we have already described. Works in terracotta produced two thousand years ago in the plateau region of Nigeria, and known as Nok sculpture as they were first found in a place of that name, show the imitation of the rhythm required by woodcarving even in the use of clay. The head found at Jema'a shows the rhythm in the slanted lines of its profile. As far as possible these characteristics have also been imitated in the stone sculptures known as *mintadi* which were made three hundred years ago in the Congo Basin. The wood sculpture itself was regarded as constantly renewing itself, and was thought in a mystical kind of way as taking on life from the tree from which it

61

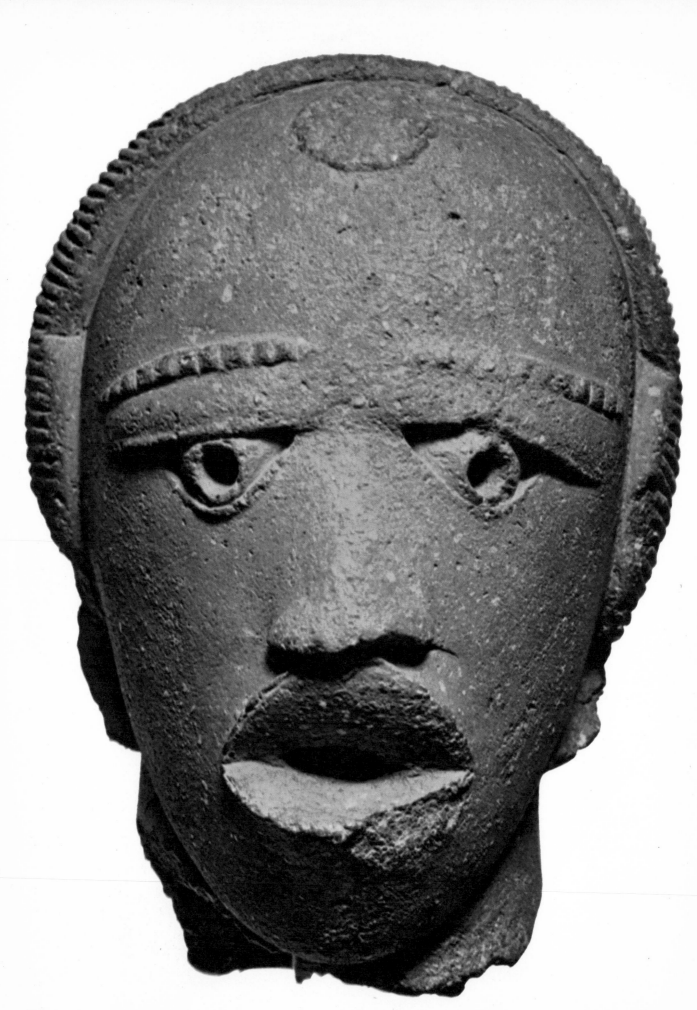

62 and 63 Jema'a head, Nok culture, Nigeria. Pitt Rivers Museum, Oxford. This terracotta, found on the Bauchi Plateau in Nigeria, is attributed to an Iron Age culture known to be at least two thousand years old. It shows the woodcarver's style influencing the moulding of the clay, and in this respect the representation of the hair should be compared with that of the figures on the Baluba headrest (plate 2). The two views of the head show how the sculptor also adopted the contrast between a static frontal appearance and a dynamic profile from the woodcarver's style.

65

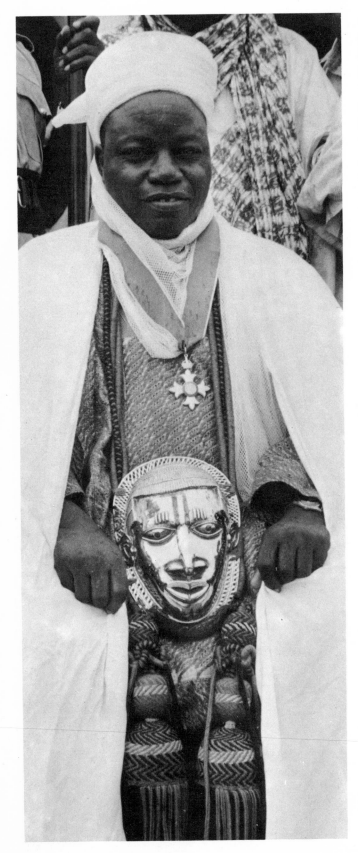

was carved. Great store was placed on finding exactly the right tree for a particular piece, and a sculptor would go many miles into the forest and spend several days or even weeks looking for it. When he had found it, special rites had to be performed, with sacrifices to the earth, before it could be cut down. The wood came from the earth and was constantly returning to the earth. In Achebe's *Arrow of God* the masks are described as coming out of the ant holes: 'Half a dozen young men were searching for the mask, for no-one knew which of the million ant holes it would come through.'

The masquerade

The identification of the spirits of the mask with the ants shows once again that the imagery of these societies was concerned above all else with ensuring that no feature of an individual's personality remained in the social group long enough to cause any harm to the group, and that all the agents of the earth were concerned with this process of ingestion and regeneration. It follows from this that we can explain why we can see two types of mask, that which might be called an ugly and distorted type, and a beautiful, more perfect type, in many societies **68** from one end of sub-Saharan Africa to the other.

For example, the Afikpo Ibos of Nigeria still have a masquerade society which puts on a performance every year to satirise the behaviour of the elders. **23** Normally the young men of the village are extremely respectful to their elders and obey their demands without question, but in these plays they are able to use the excuse that their possession by spirits when wearing the masks makes them immune to any retribution on the part of the elders. The elders are represented by dark or black masks that are distortions of human faces—'with bulging cheeks, crooked noses and mouths and ears that are out of line' (Simon Ottenberg in *African Art and Leadership*). The satire concentrates on individuals who enrich themselves at the expense of the social group and who endanger the social group by their ambition and self-regard. Over a hundred young men who belong to the secret initiation societies may take part, and the play lasts three or four hours. They use the opportunity to criticise elders, for example, who take part in unnecessarily long discussions over divorce cases and use such cases to obtain

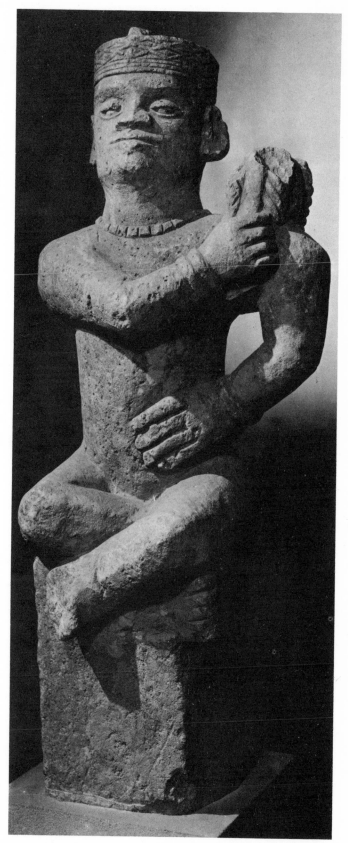

food and drink and bribes. They also report that society is changing and that the elders are not adapting themselves to the changes. However the representation of the elders with distorted faces does not mean that the young men are saying that the elders who behave in this way are bad. The women are represented with white faces with delicately ornamented lines, but the women are criticised as much as the elders, because it is said that the chánging conditions of society are giving them an opportunity to desert their traditional roles. We might conclude that the play says that it is in the nature of an elder to look after his individual welfare, and that it is in the nature of women to use their beauty to abandon their responsibilities to their children and their children's fathers. In other words the play states that adaptability to new conditions is only necessary in order to preserve the continuity of the social group and its traditions. Adaptation and innovation are not ends in themselves.

The most important conclusion we can reach about old African art from looking at these plays is that it was never concerned with ideals, and that was its great difference from Western Classical and Neo-Classical art, a difference which has escaped the attention of a large number of modern artists and historians.

Art and personality

The king's individual personality, which became the personality of his people while he was alive because it was the god-given destiny of the whole people, lasted therefore only for the period in which he lived. When he died chaos ensued, but out of the chaos arose a new individual to rule, with a new personality to impose. The art of kings often showed that it was the art of a particular individual with a particular personality because it showed actual scenes in which people were involved with one another, whereas the art of kin groups was often monyxylic, frontal and symmetrical. When we describe ancestor figures as monyxylic we mean that each piece represents one individual and that there is no action depicted which relates that individual to any other. By frontal we mean that the figure faces forwards. At the same time all the features and limbs are aligned symmetrically about

66 Ancestor figure, Ndengese. Ethnological Collection, Zurich University. Even if the legs had been carved on this figure the head would have been one-fifth of the total length instead of one-seventh, the normal proportion in human beings. In many African figures the sculptor concentrates on the head because that was thought to be the seat of the particular soul which determined a man's destiny.

67 Ancestor figure, Urhobo, Nigeria. Museum of Primitive Art, New York. Every line on this figure indicates that it was made by powerful and precise strokes of the adze.

68 Mmwo society mask, Ibo, Nigeria. American Museum of Natural History, New York. This is a kind of mask which was quite common in the equatorial forest and the surrounding regions north and south of it. It was used in masquerades to characterise a girl or woman who was overburdened with her own beauty and perfection.

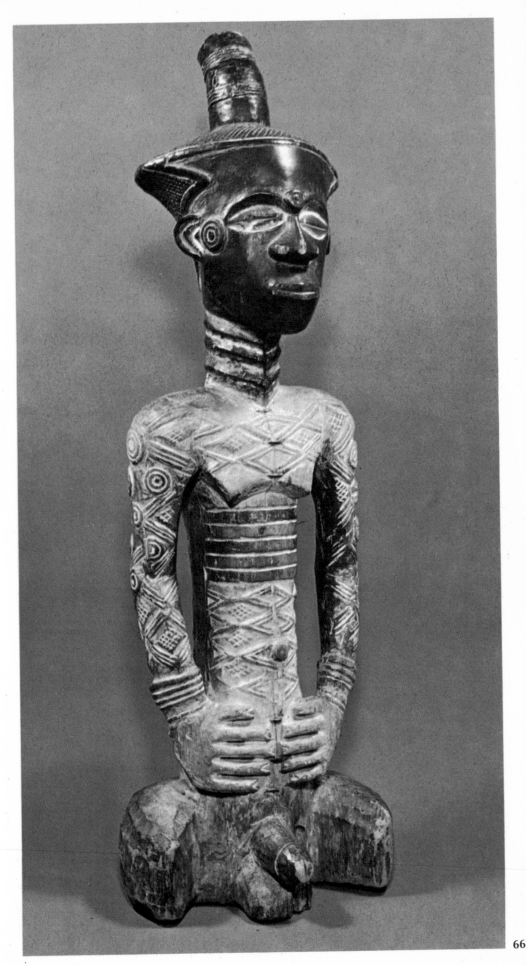

66

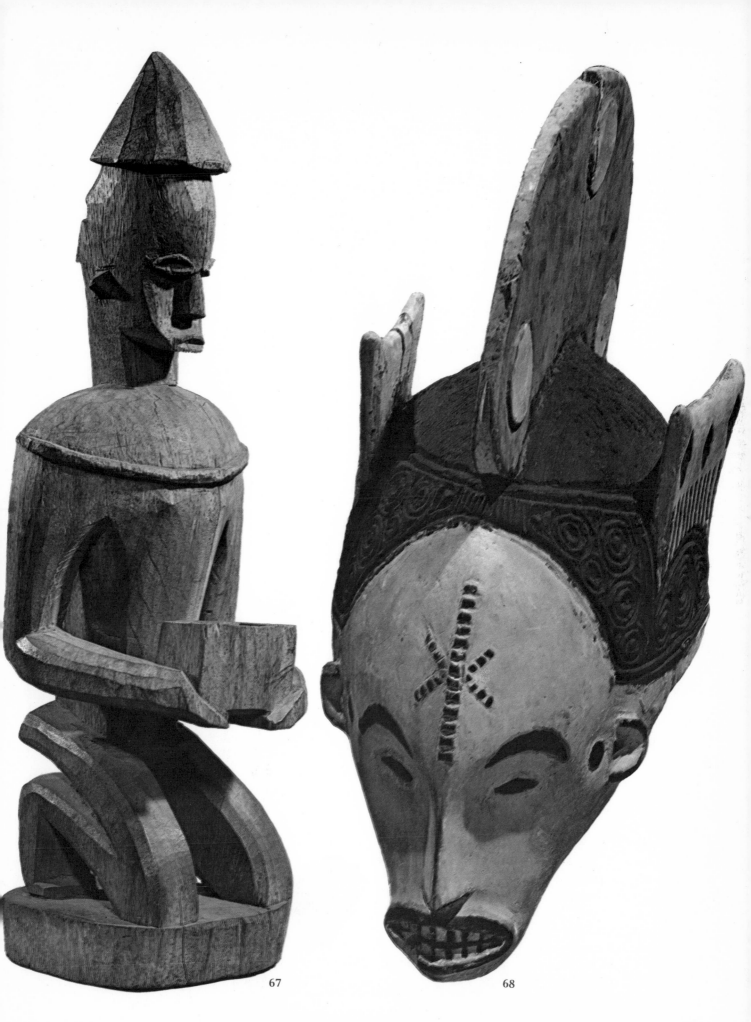

67

68

69 A pair of leopards, symbol of kingship in Benin. They are of solid ivory with copper studs. British Museum, London.

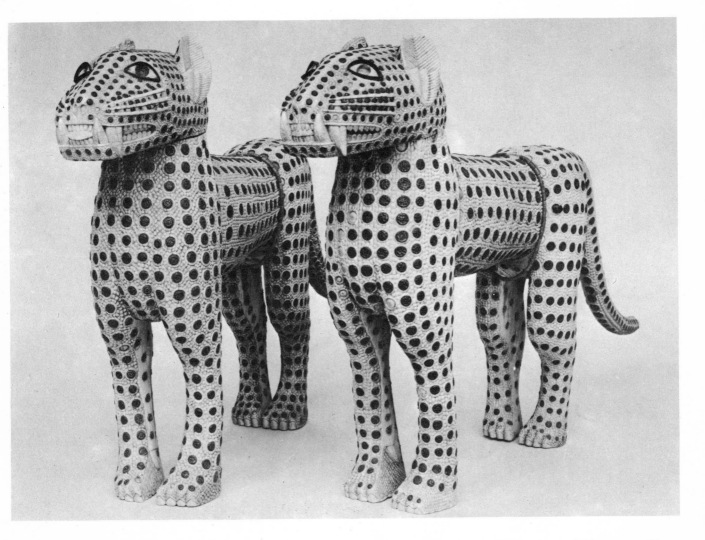

67 a single axis. The figures generally give an impression of imperturbable dignity and this effect is created by the use of horizontal and vertical planes when the figure is looked at from the front.

However, although the monyxylic figures of kin groups seem to be calm and dignified from the front, they were often composed of exaggerated diagonal planes when looked at from the side. They therefore reflected the features that we see in relation to the wife of the sea god in Amadi's novel, *The Concubine*. She is aware that the discordant elements in a society are as important as the static, orderly ones. Movement and change are as important as calm and obedience to order. African dances often reflect these two aspects of the sculpture. While the dancer has a still and trance-like expression on his or her face, the rest of his body may be moving in time to a number of different cross-rhythms.

We see then that African art and literature illustrate the difference between the personality that tries to make society conform to accustomed rules created by an environment and a particular set of circumstances, and the personality that must introduce change in relation to new forces coming from outside into the society or environment. This division was also reflected in the meaning attributed to the different souls which made up a living man's personality, and the position these souls were said to occupy in a man's body. Every man has two souls, his personal soul or character, inherited and inalienable, and his destiny soul which he can accept, shape, or even in desperate circumstances try to change with the professional help of diviners. We have also seen that the man's destiny soul, which determined the pattern of his life on earth, was given him by a sky god and lived in his head;

70 Umbrella finial, Ashanti, Ghana. British Museum, London. This illustrates the proverbial saying, 'The snake lies upon the ground, but God has given him the hornbill'. The bird symbolises the ultimate power of the matrilineages over the kings, which is general throughout Africa.

71 Bird on pillar, Zimbabwe, Rhodesia. British Museum, London. A soapstone carving of a bird shaped like a phallus on a phallic type of pillar found on shrines in huge stone palaces of sites such as Zimbabwe. They obviously represented the fertile powers of the earth and may have been kept by the priests of the earth shrines.

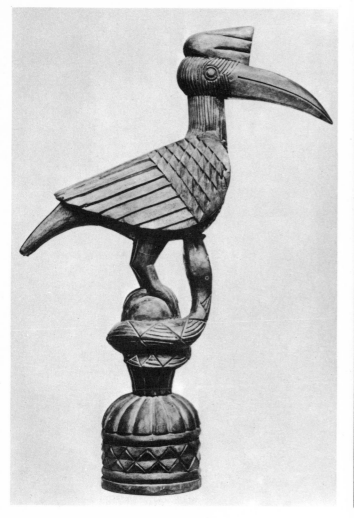

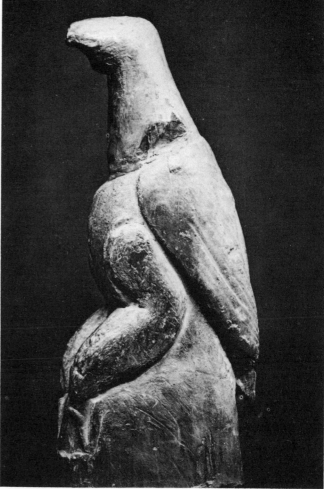

66 this might be the reason why some African sculpted figures have heads which are disproportionately large in relation to the rest of the body. It certainly explains why the bronze head was so important as part of a king's regalia. It expressed both his ability to make his personality into a lasting personality embracing the whole group that he ruled, and at the same time his ability to see clearly what was happening to his group in relation to the rest of the world. Bronze was associated both with permanence and the clarity of daylight. The art made of other materials was an art designed, on the other hand, to disappear quickly and to preserve secrets (we have already seen the importance of secrets in African art, see page 31).

We have said that the king's regalia used the symbol of the chameleon to indicate his adaptability to all the particular characteristics of the local groups to whom he symbolised unity, and that the leopard with its spots had a similar meaning when symbolising the king. Obviously the leopard also 69 symbolised the king's strength and represented the fact that he had a frightening kind of power as well as being infinitely adaptable to the vagaries of the local environment. Therefore the king himself and his court were represented in bronze and everything was clearly visible and durable, while the young men who fought for the king used the masks which were adaptable and which would disappear as they became elders and ancestors.

Kings and priests
We must be careful nevertheless to avoid imposing a rigid framework on all Bantu African societies. Sometimes priests appear to have made themselves powerful by establishing earth cults and then it is

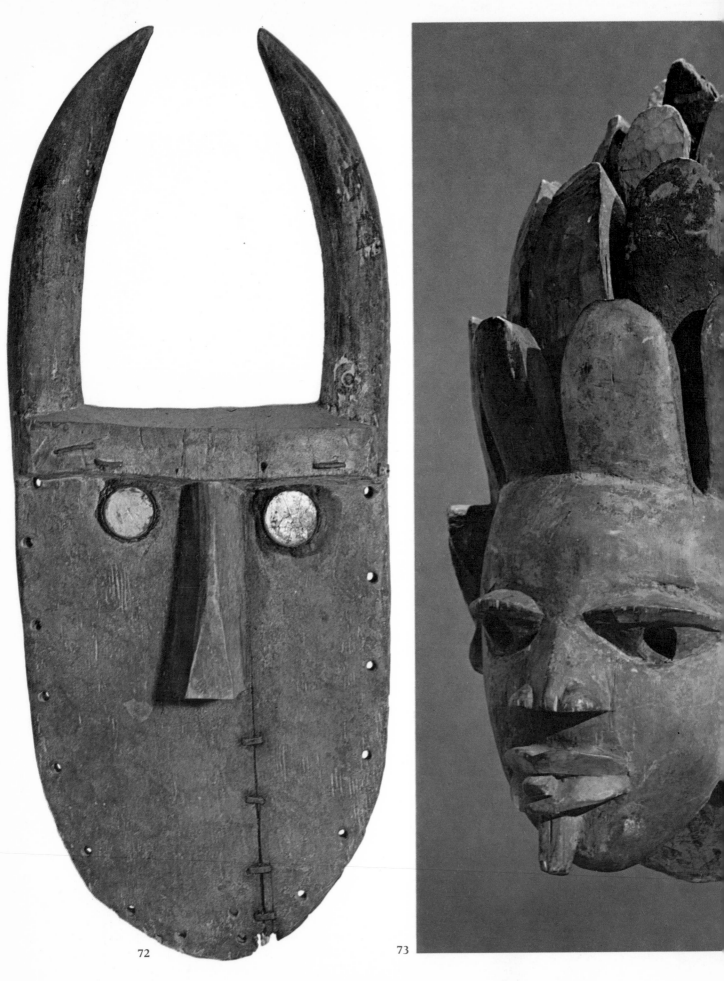

72

73

72 Mask, Toma, Guinea. Collection of Mrs Peggy Guggenheim, Venice. A mask of the Poro society which is general among wandering tribes who have migrated from the interior towards the west of Guinea, Sierra Leone, and Liberia. It is an age-group society which has similar functions to age-group societies in the whole of Africa south of the Sahara.

73 Four-headed mask, Yoruba, Dahomey. Collection of E. Muller, Solothurn, Zurich. The mask with four heads represented the spirit which understood the four-day week, with three days for the markets and one for the sky spirit. A four-faced spirit was therefore very powerful because he could see so many ways at once.

74 Battle of archers, Khargur Talah, Libya. Archers of this type do not appear in the Saharan rock paintings until about 1200 BC, the date of the incursion of the charioteers across the savannah. They were possibly of North African origin, for example the Libyan Berber race described by Herododus as the Garamantes.

74

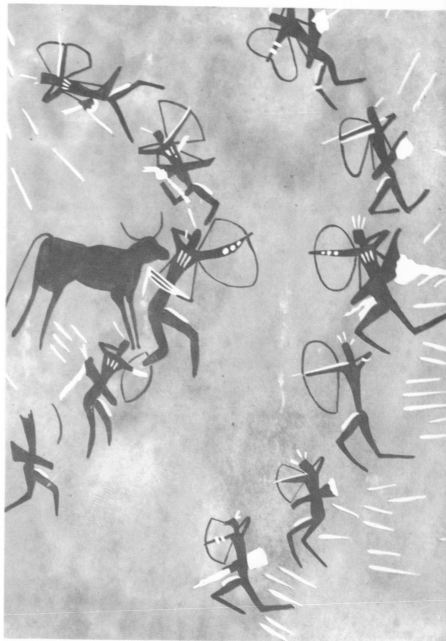

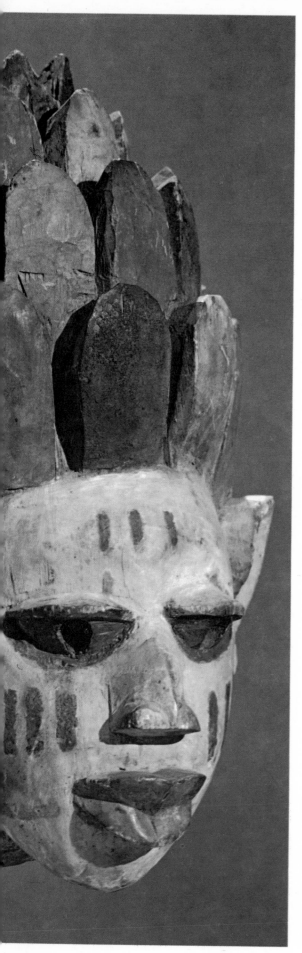

the symbols of the earth which were made out of durable materials. The stone palaces in Rhodesia known as Zimbabwe were found to contain a large 71 number of stone monoliths surmounted by birds; many of these birds had the appearance of phalluses. These monoliths were generally kept on a grooved stone platform in a shrine behind the ruler's own chamber and it must have been there that they made sacrifices, the grooves in the platform serving to channel away the blood of the sacrificed animals. The people who built the palaces at Zimbabwe, and at the 150 other known sites over a vast area between the Kalahari Desert and the Indian Ocean, are thought to have been the predecessors of the Shona people who live in the area today. They are also thought to have been a minority who were able to impose their rule by bringing with them a powerful religious cult, and not by armed conquest. It seems safe to assume, then, that they brought with them an earth cult whose symbols were the bird and the phallus, and that it was necessary to represent their permanency in stone. It might be suggested therefore that the rulers of the Zimbabwe empire which lasted from approximately AD 1000 to AD 1500 were priest-kings. They were able to support the labour which went into the building of their large stone edifices by trading in copper and

gold sold to middlemen on the coast, who in turn sold it in Arabia and the Far East. They had the same role as the priest-kings among the Ibo of eastern Nigeria at a much later period, who met at Arochukwu to confer about the retention of their power by means of religious practices. This may explain why the Zimbabwe rulers tried to keep foreigners from travelling in their empire, and why so little was known about it by the Arabs and the Portuguese. Nevertheless, if priests obtained too much power, many African societies ensured that they were defeated by the kings controlling the age-groups. We find an extreme example of this in the Zulu king, Shaka, who carried out the wholesale destruction of his 'witches'. In all Bantu societies south of the Sahara we find the equilibrium maintained between the kings and the priests, between the sky and the earth, with the age-group or initiation societies sometimes supporting one, sometimes the other, and expressing their ambivalence in the carved wooden figures deliberately made of perishable materials.

As elders became ancestors they were represented in wood in such a way as to look like the boughs of trees and phalluses at the same time. These figures stayed in the family shrines for three or four generations and then disappeared, eaten by ants. Sometimes they were thrown into the forest to hasten the process of their return to the earth. To represent the fact that they had been enshrined as ancestors however, and that therefore their spirits had to be summoned to assist at important crises in life, they were represented by a severe frontality. Their figures were composed of strong horizontal and vertical planes and they looked straight forward. Thus they were given a temporary permanence and durability.

Ancestors were often represented sitting on stools because the stool was an important symbol of authority in sub-Saharan Africa. In matrilineal societies it was often the female ancestor who was 55,81 represented. Among the Tsui-speaking peoples of Ghana, the spirits of dead kings were annually given sacrifices at the place where their stools were kept, and chiefs among the Ibo-speakers of Nigeria were buried sitting on their stools when they died.

The kings of the Ashanti in Ghana were also associated with the sky because the golden stool

76 Stool, Afo, Nigeria. Collection of D. G. Duerden.
This stool was used by a woman to sit in the market.
Made by turning the trunk of a tree rapidly while
cutting rhythmically with an adze, it shows by the
marks left on its surface that each stroke had a
rhythmic precision.

of the first king, the first Asantahene, was said
to have descended from the sky. However the
power of the earth, symbolising the indigenous
inhabitants whom the royal kings came to rule,
was emphasised by the fact that the royal stools of
the first Asantahene's successors were painted
black with a mixture of earth and eggs each year,
and their sacrifices might not be offered until the
queen mother appeared.

The important mark of royalty in Ghana and
generally throughout Africa was the king's umbrella.
It indicated that the king could provide shade
from the sun for the earth and it was also associated
with the king's power to bring rain. The sky spirits,
belonging to the king's cult, were associated with
the tallest trees in the forest, and dark clouds were
said always to be seen hovering over the trees at
the shrine of the sky spirit.

Trade and the growth of the kingdoms

The origin of the Iron Age in African societies is
erroneously attributed to the spread of the know-
ledge of ironworking from Mesopotamia, or from
other sources outside Africa. The rise of the kingdoms
has also been attributed to this outside source
because it has been connected with the use of iron
weapons. However although the African Iron Age
appears to have started at the beginning of our
own era, the kingdoms developed much later and
probably for quite different reasons. It is true that
we can see the incursion of a race of charioteers in
the rock paintings between about 1000 BC and
AD 500, and that the best routes across the continent
are clearly marked by the sites of the paintings,
one to Agadez from Tunis and the other to Gao on
the Niger. It is also true that the particular kind of
bow that they used is to be found in representations
of archers from the same period. Herodotus described
archers with chariots in the middle of the Sahara
in the region of Agadez in the fourth century BC
and called them the Garamantes. However the
African kingdoms with semi-divine kings or priests
began to appear nearly a millennium later and
then simultaneously on both sides of the equatorial
forest region. Thus we find that the Ife terracottas
and bronzes have been given carbon datings placing
them between AD 700 and AD 800, while the
Zimbabwe stone buildings were being constructed

soon afterwards. It seems more probable that small
centralised kingdoms grew as the result of trade
with the outsiders who visited the coast and who
sometimes built large towns or forts there, as did
the Arabs at Kilwa. The techniques of mining and
smelting which produced the goods for trade were
already well known by the people who founded
these kingdoms, however, in the same way that
their knowledge of working stone produced some
of the most beautiful and carefully worked stone
arrow heads and axes which are found all over the
Sahara in vast quantities.

Each one of the small kingdoms grew out of a
village whose chiefs grew prosperous on the trade
in metals which they already knew how to work
with great skill. In West Africa and on the western
seaboard of Central and Southern Africa there were
already markets in existence rotating from place
to place on a three-day basis. The fourth was
devoted to the sky god, and a particular kind of
mask was produced of a figure who looked in all
four directions. This was the deity of the particular
area in which the markets took place and he needed
to keep all activity under his eyes. The people who
organised these markets now began to trade with
visitors from the sea in a limited way, and to extend
their power over large areas inland, but while

77 Ci Wara mask, Bambara, Mali. Collection of M. Pierre Verité, Paris. This is a similar mask to the ones worn by the elders in plate 32. It has a very different appearance when photographed in a private collection. The antelope carrying a smaller antelope is a common theme and seems to stand for the teaching responsibilities of the elders.

78 Do guardian spirit, Bobo-Fing, Upper Volta. Rietberg Museum, Zurich. The people who used this mask are neighbours of the Bwa people who made the costume of leaves in plate 59. The mask was used in a ceremony in which the young men returned from the bush dressed in leaves and fibres and met the elders wearing masks such as this one.

79 Mask, Bafo, Cameroon. Museum für Völkerkunde, Berlin-Dahlem. The peoples who used this mask and the peoples who used the Night society mask (see plate 82) all belong to a group with similar languages and social structures who live in the northern highlands of Cameroon. The largest of these are the Bamileke. They live near to the area from which the Bantu-speaking peoples originate, and all have a cult of skulls thought to represent a man's destiny spirit (see caption to plate 66). This mask, belonging to an age-group society, seems to represent a skull.

77

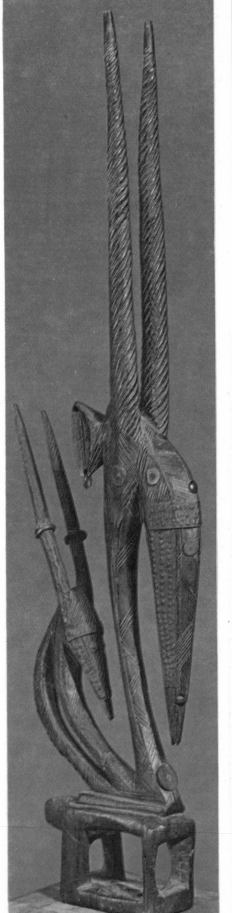

78

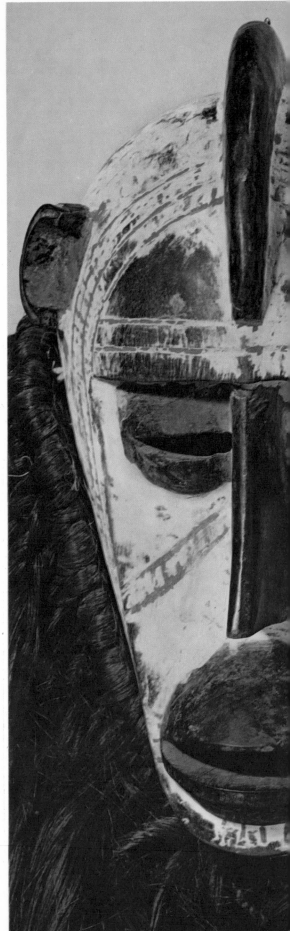

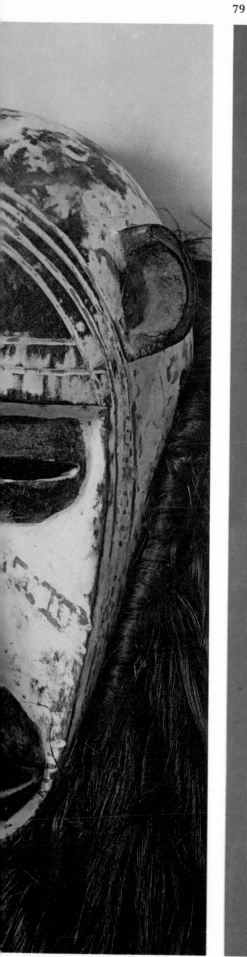

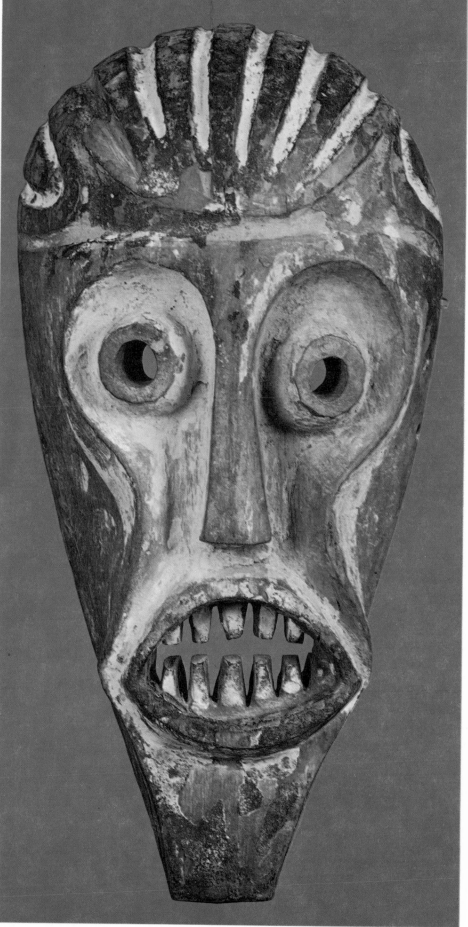

80 Paramount chief and his retinue, Ashanti, Ghana. The Asantahene, the king of the Ashanti, kept a number of umbrella-like canopies for state occasions and so did the chiefs in his confederacy. The umbrella form expressed the overall power of their office, and their ability to cast a shadow over their people, thus shielding them from the sun. They were a symbol of wide, general and regulative powers.

they did this they retained the old religious basis of their authority. Consequently they never grew so big that their courts could not reflect the demand of the social group that they should be a microcosmic reflection of the life and health of the whole community. In order that this should happen the king accepted all the restrictions on his power that we have described and voluntarily accepted the status of a slave to the cult of his ancestors, never leaving his palace except on ritual occasions. The masks of the age-group societies, by acting as intercessors between the king and the village elders, supporting sometimes the one, sometimes the other, assisted in the process of circumscribing the king

and ensuring that this power should not destroy the organic structure of the society. Consequently we can relate the kingdoms and groups of chiefs to the masks which were produced (and which are still being produced although their rationale is often being quickly forgotten).

The kingdoms coexisted with societies which were similar to those from which they themselves had developed. It was sometimes necessary for them to leave such societies in their original state and not to try to coerce them into accepting representatives of the king as their local overlords. It might be that the societies consisting of autonomous village units inhabited physically inaccessible

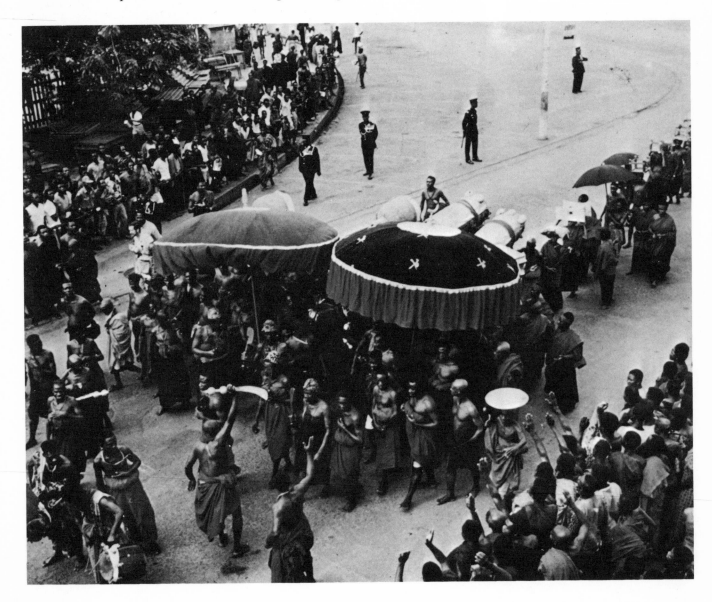

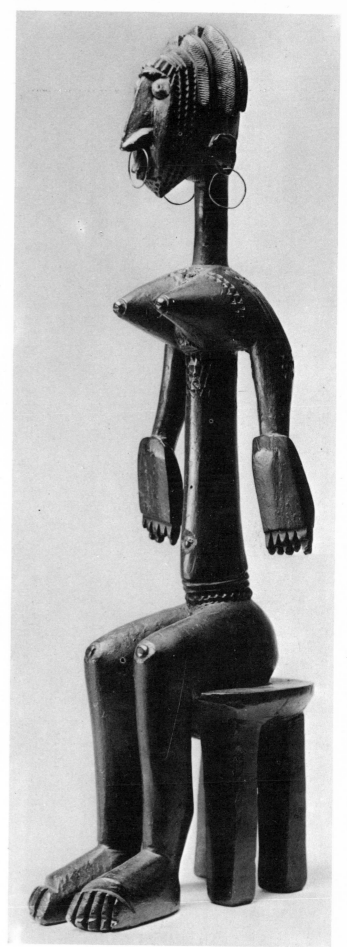

areas, or it might be that attempts at coercion would drive them away, either to seek new territories in which to live or to give their allegiance to a neighbouring kingdom.

In the masks in plates 72, 77 and 78, from the Manding-influenced area of the western Sudan, we see the work of the people who remained attached to their old religion despite the fact that they were surrounded by Islamised kingdoms. They were able to retain this attachment because their masks were closely connected with agricultural practices and with the seasons. The old empires of Ghana and Mali knew that they needed to give the social groups within their boundaries a great deal of autonomy because otherwise they would lose them to new kingdoms springing up on their peripheries, and their successors, for example the Songhai, the Mossi, and the Hausa, were also aware of the need to understand local susceptibilities.

Therefore the Do mask of the Bobo-Fing (plate 78) of Upper Volta was used by a society which itself was not centralised but consisted of a number of small villages. Nevertheless it existed in an area which was conquered by a Manding group of invaders who had adopted the Islamic religion and not only allowed the traditional masks to continue to be used but sometimes used them in their own funeral ceremonies. The masks were representations of the spirits who taught men the rules which they had to obey in order to live in a regulated community. It is easy to see therefore why they would be tolerated by an invader who wished to ensure that the local inhabitants would live in an orderly and peaceful manner, and continue to grow the crops upon which the survival of the whole society depended.

In the next four masks (plates 79, 82, 83 and 90) we find the work of societies which did not need to accommodate themselves to the centralised kingdoms because they inhabited inaccessible places, the Bafo and the Bangwa in the mountainous areas, and the Ibibio in thick forests. Nevertheless their masks performed exactly the same functions as those of the groups who lived within the boundaries of the Sudanic kingdoms, worn by young men who carried out the dual role of policing the community and at the same time making its discontents apparent to the chiefs or elders.

82 Night society mask,
Bangwa, Cameroon.
Rietberg Museum, Zurich.
This mask was used by the
most important secret
society of the Bangwa. The
mask produced an
ambivalent attitude in the
person who looked at it–
a mixture of fear and
amusement.

83 Mask, Ibibio, Nigeria.
Linden Museum, Stuttgart.
A mask with a hinged jaw
of an Ekpo society of some
people not far from the Edo
of Benin, whose Ekpo
masquerade is shown in
plate 46. This mask fulfilled
the functions of a young
man's age-group society
which carried out the
community sanctions on
wrongdoers, but this one
comes from a society which
had no king.

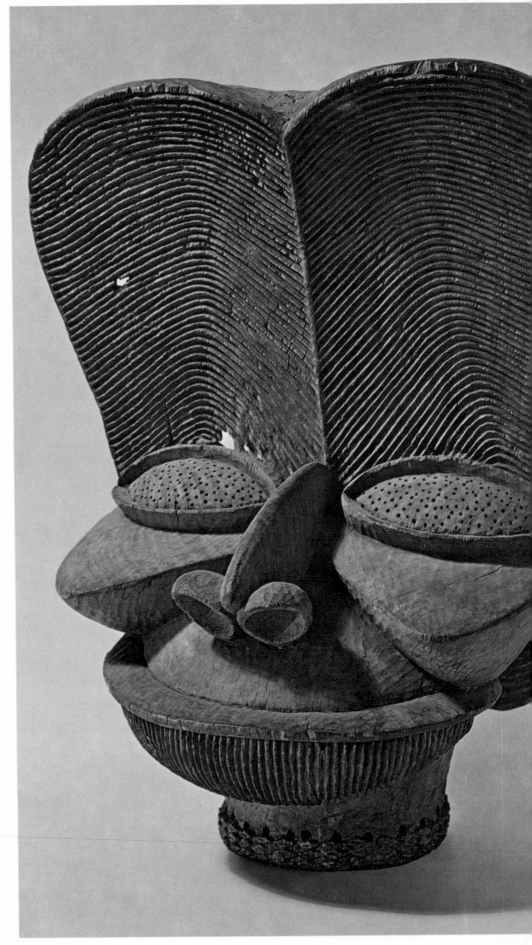

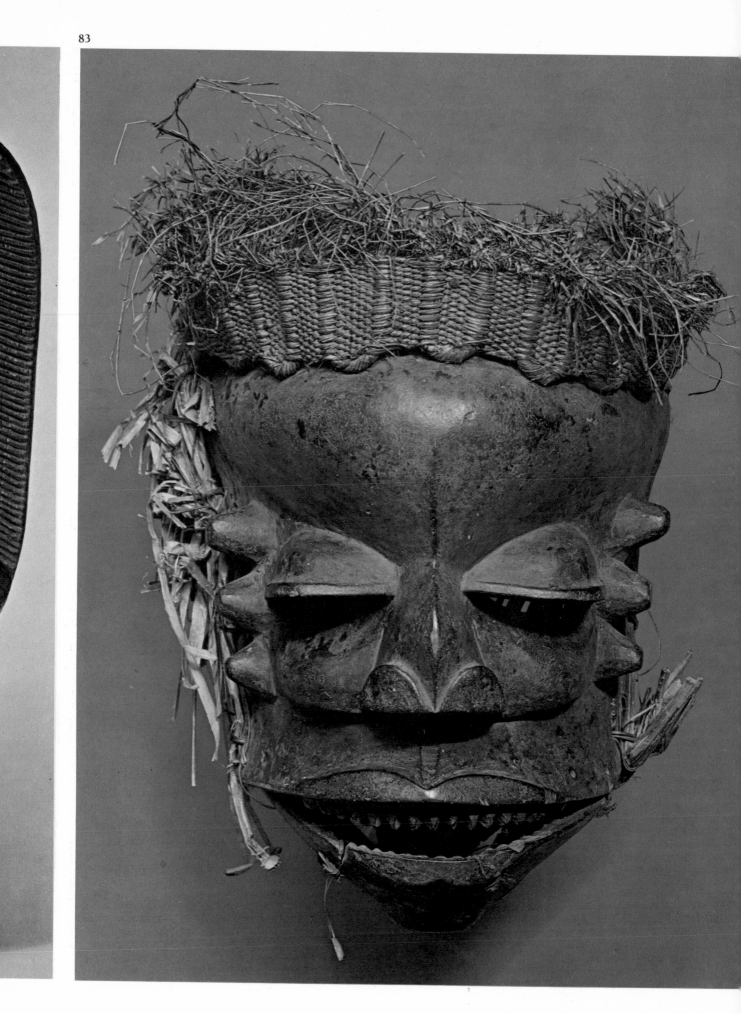

84 Mask of Eshu, Yoruba, Nigeria. This mask is used
in the Egungun masquerade. All heads and figures of
Eshu are represented with long hair.

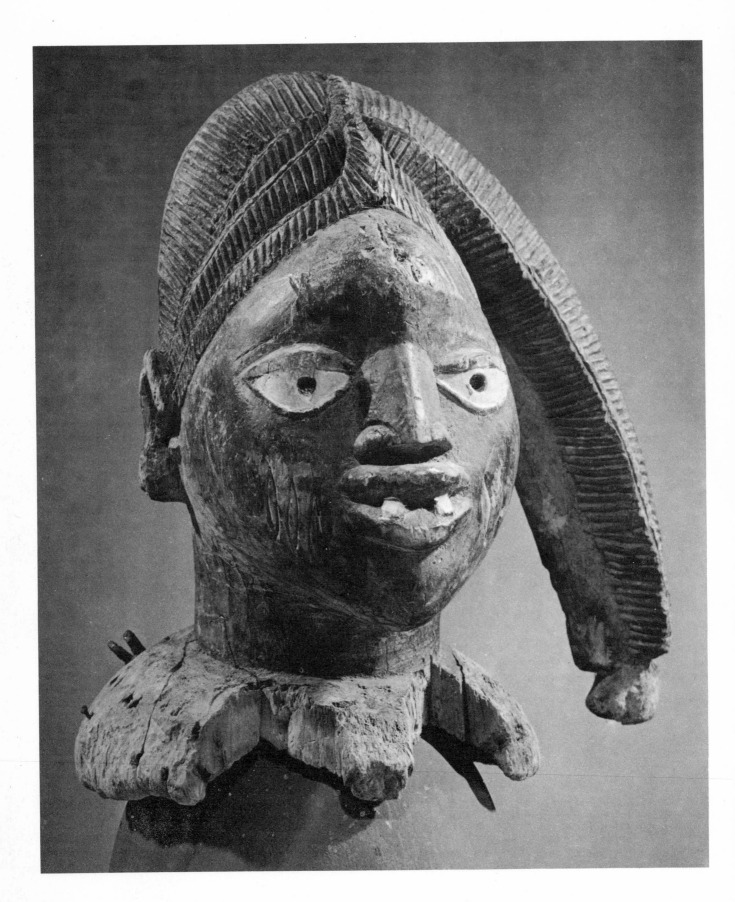

AFRICA
in contact with the Western world

In this book I have tried to dispel some of the popular (and even scholarly) misconceptions about the nature and origins of African art. European observers have always looked for its roots in some civilisation they were more at home with, generally Ancient Egypt and Greece. But there is evidence which tends to show that the influence was that of Africa on Egypt and Greece, not the other way round.

A symbol which is constantly compared all over the Saharan area is the bull or cow with the solar disc between its horns. The same symbol of the sun between the horns is seen in representations of the Egyptian goddesses Hathor and Isis, as well as being found in more recent Nubia and Ghana on opposite sides of the Sahara. In the light of what we know about recent African society (for example the widespread practice of burying kings in ox skins), it appears that the horns of the cow or bull may have represented the earth's control over royalty. Thus a bull with a disc between its horns in the rock paintings represented a king with the gift of power from the sun, but also born of the earth. We might also conclude that Isis, the

86 Egyptian goddess, the Egyptian queen mother, was similar to the queen mother who still played an important part in those African societies where the king was buried in an ox skin until recently, and in many other sub-Saharan societies where she appeared to symbolise the power of the indigenous inhabitants who came out of the local earth and allowed foreign royal clans to rule them. Queen of the night, goddess of the moon, and associated with

85 the snake (in African art fertility figures are often represented as ithyphallic), it was she who represented the earth to which the king returned when he died; her horns turned into the moon, but the king's solar disc returned to the sun whence came his foreign ancestry. (In the myths about Hathor, she became a sky goddess when she was asked to

transport Re, the sun god, into the sky, because he had become tired of the earth. This myth is similar to the African myth that the creator god moved further away from the earth because he was hit on the nose by a woman pounding her mortar. This myth is found both in East and West Africa.)

Nowadays, therefore, it seems unlikely to us that it was Ancient Egypt which had a great influence on the cultures of Africa south of the Sahara. There are important similarities between sub-Saharan African art and religion and Egyptian art and religion, but it seems more likely that it was Africa that influenced the culture of Ancient Egypt rather than the other way round. However, until recently the myth that the most important features of African culture derived from Ancient Egypt has been an important basis of books by historians, social anthropologists, travellers and other observers. There seems to be a great reluctance, even at the present day, to admit that any of the seminal ideas in the history of art and literature could have derived from sub-Saharan Africa. Frobenius, the great German traveller and discoverer of Africa, preferred to attribute the bronze sculpture of the Yoruba at Ife in western Nigeria to an Etruscan artist from the lost Atlantis of Plato's myth rather than to local genius.

It seems probable that the figure of Hathor, the cow goddess, whose identity Isis later assumed, originated in the central plateau of the Sahara in the light of evidence of a knowledge of mummification which has been found in that area dating to as far back as 6000 BC, and therefore pre-dating pre-Dynastic Egypt; that Isis was supposed to have introduced mummification to Egypt; that the early characteristics of Egyptian mummies are similar to the example found in the Sahara, that is placed in a foetal position facing the east; and that the symbols used on Isis figures, the horns and the solar disc, are found much earlier in the cave paintings. It

85 Olokun head, Yoruba, Ife, Nigeria. Ife Museum, Nigeria. This head is over a thousand years old. The spike with the disc surmounting the forehead is a common motif in old African sculpture. Could it be derived from the bird-snake in the rock paintings, and the uraeus in the representations of Isis?

86 Isis holding a sistrum, Temple of Seti I at Abydos. Ninteenth Dynasty. Isis is sometimes represented with a bird, sometimes with a snake, issuing from her forehead, symbols of clairvoyance and the cult of the earth in Africa even today. In this example she has both at the same time. The horns and the solar disc are found in the rock paintings six thousand years old and are represented on buildings in the area of the northern Sudan decorated recently (see plate 14).

85

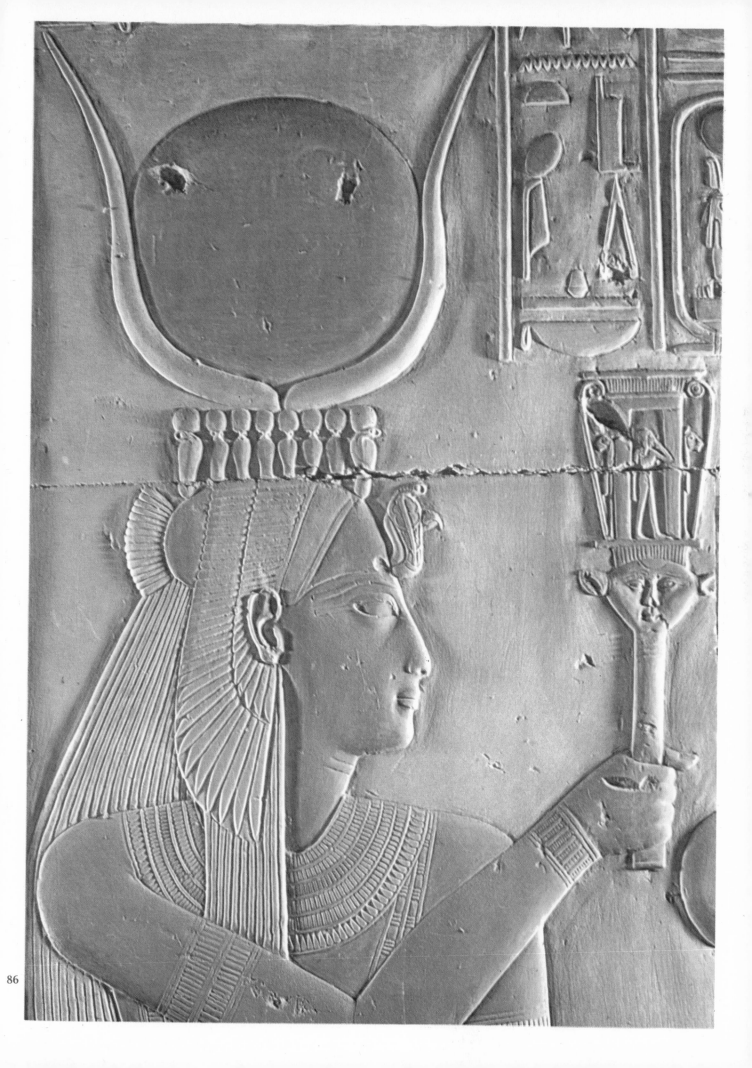

87 *Dancer* by Vincent Kofi, a modern Ghanaian sculptor. The sculpture in wood of this and plates 88, 89 and 92 shows the similarity of style among modern sculptors from four African countries.

88 Sculpture by Paul Ahyi, a modern Togolese artist.

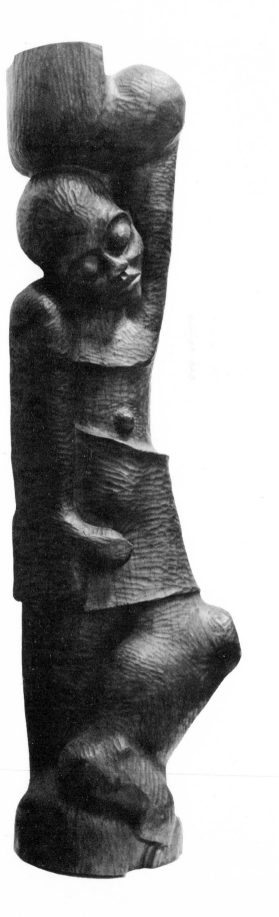

might also be worth exploring the hypothesis that the chthonic or earth gods of Crete and Ancient Greece actually originated in the central Sahara and that this explains their resemblance to such gods **84** as Eshu (Hermes) and Ogun (Dionysos) of the Yoruba people of Nigeria and Dahomey.

Modern art

We have seen that old African society was a society in which a man's rhythms of life were regarded as peculiar to the special circumstances in which he was born and grew up. The personality of his clan, the personality of his immediate ancestors, and of his particular age-group determined his behaviour. The laws made by particular rulers were temporary and the product of their individual personalities. There were no higher spheres in the Platonic sense from which man derived the pattern for his behaviour. Each man or woman adapted themselves to their circumstances with the help of diviners and the end of their adaptation was the production of life.

Modern African artists have steered an uneasy path between the assumptions still implicit in much of the behaviour of their societies. They find themselves forced to produce work for a Western art market which shows little or no understanding of their own tradition. Sometimes European patrons have encouraged them to mould themselves in an Expressionist or Surrealist manner. Therefore it may not be surprising that the most successful painters from Africa are those from the Sudanese Republic and from Ethiopia, with Islamic and Christian traditions respectively. Two examples of work by such painters are illustrated here, one by Ibrahim **93** El Salahi of the Sudanese Republic, and one by **94** Skunder Boghossian from Ethiopia. (The latter is now teaching at Howard University in the United States.) Both seem to lean heavily on European traditions and both spent the early part of their careers in Europe.

In recent years there has been a distinctive sculptural style evolving among modern African artists. It might be predicted that modern Africa would produce its own sculpture in wood, and a form of sculpture which pays particular attention to the form and shape of the trees from which it comes. It is therefore worth comparing the four

90 Mask, Bakwele, Peoples Republic of the Congo. Collection of M. Christophe Tzara, Paris. This is the feminine-beautiful type of mask of a people living on the southern fringes of the equatorial forest who make two varieties of mask, an ugly and a beautiful kind. This practice is also carried out by the Ibo of Nigeria on the northern fringes of the forest, whose beautiful type of mask is shown in plate 68 and whose ugly type is shown in plate 23.

91 *Les demoiselles d'Avignon*, 1907, by Pablo Picasso.
Museum of Modern Art, New York (acquired through
the Lillie P. Bliss Bequest). Picasso's personal reaction
to African art can be seen in the heads of the two
figures on the right.

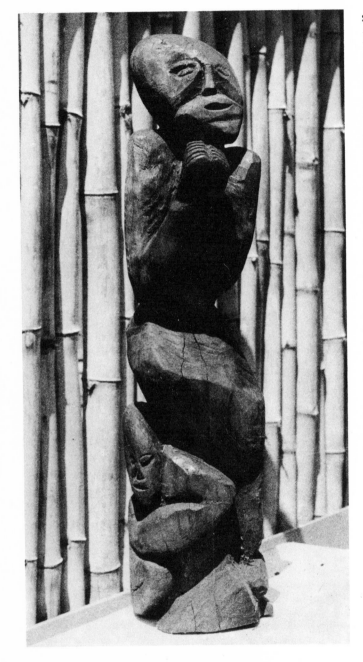

examples shown here to see how the work of
87,88 Vincent Kofi from Ghana, Paul Ahyi from Togo,
89,90 Demas Nwoko from Nigeria, and Mwariko Omari from Tanzania, all demonstrate a very similar style although they work in different countries, separated from one another by long distances.

The fact that Vincent Kofi left a sculpture called *The Horn Blower* outside Nkrumah's rest house, Peduasi Lodge, to be eaten by ants after the coup d'état in Ghana in 1966, shows his awareness that a sculpture is made for a particular time and a particular place, and not for a connoisseur's collection or a museum vault where its type and dimensions can be kept as data for a computer. Kofi made a piece of sculpture called *Birth of Ghana* after his country's independence celebrations. Talking about it he has said, 'Living at that particular time and being able to record what was happening merged with my materials, which is how much of my work often occurs.' He has also stated that, 'Art exposes both the tradition and aspirations of a people, what they have experienced in the past and what they consider desirable for the present and the future.' In his attitude to his materials we also find something of the old African sculptor's sense that the wood with which he works still retains the life of the tree from which it was cut: 'I had a piece of wood and I could see a burnt part and it looked so much like a mouth. . . Now, from there I had to bargain with my wood . . . give and take . . . until finally I was able to work it' (see Grobel, Victor, 'Ghana's Vincent Kofi').

The work of these modern African sculptors, however, does not express the idea of a unique rhythm of a particular social group which we have seen in the old African sculpture. Their work is much more concerned with a rhythm in nature: the surface of the work shows the rhythmic use of tools, and the form retains the original living form of the wood as it came from the tree, but there is no evidence of the form itself emerging from the rhythmic movement of the sculptor carving the wood as it did in the hands of the old sculptors.

Kofi walks round his huge sculptures; they are made to be walked round he tells us. Looking at the work of Paul Ahyi and Mwariko Omari we can see that they too are meant to be walked round and are made in the same way. They are distinctly different works, therefore, from those of the old African sculptures which were small enough and manageable enough to be turned round as the sculptor rhythmically worked with his adze. Only the sculptures of Demas Nwoko are small enough to retain the scale needed for the rhythmic form, but he, with his Western art education, has not served the years of apprenticeship required to obtain the rhythmic pattern in the strokes of the adze and instead has used the Western chisel.

BIBLIOGRAPHY

The following books and articles have been quoted in the text:

Achebe, Chinua, *Arrow of God*, Heinemann, London 1964

Aido, Ama Ata, *Anowa*, Longmans, London 1970

Amadi, Elechi, *The Concubine*, Heinemann, London 1966

Awoonor, Kofi, *This Earth, My Brother*, Heinemann, London

Bastin, Marie-Louise, 'Arts of the Angolan Peoples III' in *African Arts*, Spring 1969

Fraser, Douglas and Cole, Herbert M. (editors), *African Art and Leadership*, University of Wisconsin Press, 1972

Grobel, Victor, 'Ghana's Vincent Kofi' in *African Arts*, Summer 1970

Junod, J. P., *Bantu Heritage*, Horton Limited, Johannesburg 1938

Soyinka, Wole, *The Road*, Oxford University Press, London 1965

Author's note

A comprehensive bibliography of books on African art was published by the International African Institute, London, compiled by J. P. Gaskin under the direction of Guy Atkins. Most of the works surveying the whole of African art that have been written so far, however, appear to me to be extremely misleading, because they start with prejudices created by the Western artists who first drew attention to the fact that African objects in European museums were works of art. It is better to be guided by the specialist papers listed below than by the works surveying the whole field.

Achebe, Chinua, *Things Fall Apart*, Heinmann, London 1958

African Arts, quarterly magazine published by the Institute of African Studies, University of California at Los Angeles, USA

Amadi, Elechi, *The Great Ponds*, Heinemann, London 1969

Beier, Ulli, *A Year of Sacred Festivals in One Yoruba Town*, Lagos Museum, 1969

Bradbury, R. E., 'Fathers, Elders and Ghosts in Edo Religion' in *Anthropological Approaches to the Study of Religion* (edited by Michael Bauton), Tavistock Publications, London 1968

Brain, Robert and Pollock, Adam, *Bangwa Funerary Sculpture*, Duckworth, London 1971

Fagg, William, *Nigerian Images*, Lund Humphries, London 1963

Fortes, Meyer, *Oedipus and Job in West African Religion*, Cambridge University Press 1959

Garlake, Peter S., *Great Zimbabwe*, Thames and Hudson, London 1973

Goldwater, Robert, *Primitivism in Modern Art*, Vintage Books, Random House, New York 1967

Goody, Jack, *Death, Property and Ancestors*, Tavistock Publications, London 1962

Goody, Jack, *The Myth of the Bagre*, Oxford University Press, London 1972

Henderson, Richard N., *The King in Every Man*, Yale University Press, 1972

Herskovits, Melville J., *Dahomey, An Ancient West African Kingdom*, New York 1938

Horton, Robin, 'Recent Finds of Brasswork in the Niger Delta' in *Odu*, vol. 2, no. 1, July 1965

Horton, Robin, 'The Ekine Society, Borderland of Religion and Art' in *Africa*, J. I. A. I., vol XXXIII, no. 2, London April 1963

Horton, Robin, 'The Kalabari Workview: An Outline and Interpretation' in *Africa*, J. I. A. I., vol. XXXII, no. 3, June 1962

Horton, Robin, 'African Traditional Thought and Western Science' in *Africa*, J. I. A. I., vol. XXXVII, no. 1, January 1967

Kubik, Gerhard, 'Masks of the Mbwela' in *Geographica* no. 20

Lajoux, Jean Dominique, *Merveilles du Tassili n'Ajjer*, Editions du Chène, Paris 1962

Laude, Jean, *La Peinture Française et L'Art Nègre*, Editions Klingsieck, Paris 1968

Leiris, M. and Delange, J., *African Art*, Thames and Hudson, London 1968

Lloyd, P. C., 'Sacred Kingship and Government among the Yorubas' in *Africa*, J. I. A. I., vol. XXX, 1960

Morton-Williams, Peter, 'The Yoruba Ogboni Cult in Oyo' in *Africa*, J. I. A. I., vol. XXX, no. 4, October 1960

Morton-Williams, Peter, 'Yoruba Responses to the Fear of Death' in *Africa*, J. I. A. I., vol. XXX, no. 1, January 1960

Morton-Williams, Peter and Westcott, Joan, 'The Symbolism and Ritual Content of the Yoruba Laba Shango' in *Journal of the Royal Anthropoligical Society*, XCII, part I, 1962

Parrinder, E. Geoffrey, *Religion in an African City*, Oxford University Press, London 1967

Senghor, L. S., *Liberté I: Négritude et Humanisme*, Le Seuil, Paris, 1964

Soyinka, Wole, *Kongi's Harvest*, Oxford University Press, London 1967

Towa, Marcien, *Léopold Sédar Senghor, Négritude ou Servitude?* L'Editions CLE, Yaounde 1971

Vansina, Jan, *Kingdoms of the Savannah*, University of Wisconsin Press, 1966

Werzel, Marian, *House Decoration in Nubia*, Duckworth, London 1972

Westcott, Joan, 'The Sculpture and Myths of Eshu-Elegba, the Yoruba Trickster' in *Africa*, J. I. A. I., vol. XXXIX, April 1962

Willett, Frank, *Ife in the History of West African Sculpture*, Thames and Hudson, London 1967

Williams, Dennis, 'The Iconology of the Yoruba Edan Ogboni' in *Africa*, J. I. A. I., vol. XXXIV, no. 2, April 1964

64771